OUTDOOR PHOTOGRAPHY

An Outdoor Life Book

OUTDOOR PHOTOGRAPHY

by Erwin A. Bauer

OUTDOOR LIFE

Sunrise Books / E. P. Dutton & Company, Inc.
New York

Contents

Foreword

ALONG WITH fishing rods, guns, and camping equipment, today's outdoorsman is almost certain to carry a camera, or to be giving the idea serious consideration. The reasons are many, but the strongest of all is the knowledge that only by using his camera can the outdoorsman record permanently, and accurately, the high points of an adventure. The 10-pound bass, the royal elk, the brace of pheasants are soon gone. But photographs bring the adventure to mind time and again for years to come. Cameras add to the pleasure of the trip and this accounts for the astronomical increase in cameras carried to the fields and forests in recent years.

Today's cameras are technological wonders. There are cameras and films that fit neatly into the outdoorsman's needs as well as his pack. And if he does not care to equip himself with the most versatile camera, there are even models that fit into the pocket of his hunting shirt. Wherever he goes in the outdoors, the modern sportsman can be equipped to make excellent pictures with minimum trouble.

But photographic quality can vary. There are always those pictures which "didn't come out," and every photographer, even the professional, has them.

This is why Erwin Bauer's excellent book can bring new rewards to any outdoorsman. By studying it, one can increase the percentage of pictures that he is proud to have in his collection of outdoor photographs.

The lengths to which an outdoor photographer will go to obtain exciting pictures are sometimes spectacular. Few photographers in the world have traveled more with their cameras than has Mr. Bauer. He has photographed jaguars in Central America, grizzly bears in Yellowstone, king salmon in Alaska, and escaped from charging bull elephants in Africa after lingering to make "just one more shot."

These travels have brought his pictures to countless magazine pages and covers, to make him one of the best known of all outdoor photographers. His book *Treasury of Big Game Animals,* contains one of the finest collections of wildlife pictures ever made by one person.

Mr. Bauer's experiences make this photography book of special value to camera-carrying sportsmen everywhere.

GEORGE LAYCOCK
Cincinnati, Ohio

Introduction

EVERY OUTDOORSMAN can multiply his pleasure in the field by carrying a camera and making the best use of it. He can use the camera only to record the big moments of any hunting or fishing trip, or he can go afield specifically to take pictures. Either is fascinating, rewarding, and, I contend, the most interesting hobby a person can pursue. For me the camera has been the key to high adventure. It can be the same key for anyone.

Take, for example, my friend Abner Childress, whose natural habitat is any north Florida piney woods. He would rather hunt wild turkeys than eat, and during the open season he is a stranger to his family and friends. Ordinarily Ab has bagged a fine old gobbler or two before the season ends, but last fall he had to *buy* his Christmas turkey. It was the first time since he started hunting.

"But I never had so much fun *not* shooting a bird in my life," he admitted.

It all began with a birthday 35mm camera. On scouting trips (for turkey) before the season opened, Ab carried the camera with the intention of shooting pictures of the birds he saw. But it wasn't easy. He came up with several rolls of disappointing shots and quickly realized he had to approach much closer than shotgun range. It became a challenge rather than a disappointment, and he passed up shooting for taking pictures. The slides of a tom he finally obtained were worth far more to him than any bird he ever shot.

Ab Childress isn't putting aside his shooting irons to become a photographer, mind you, but he *has* discovered a whole new world of pleasure outdoors.

I know the thrill of Ab's discovery. I've been an addicted big-game hunter for a long, long time and have been lucky enough to hunt in scattered corners of the globe. Bagging an ugly Cape buffalo and a handsome Stone sheep must rate among my greatest thrills. But neither event quite compared with the first time I captured an equally ugly buff and an equally elegant ram on color film. You work harder, on the average, and you sweat more to film *any* animal—but you also enjoy it more.

OUTDOOR PHOTOGRAPHY

1 The Outdoor Camera

OUTDOOR PHOTOGRAPHY is seldom an easy, undemanding adventure. I'm not saying that it is drudgery or even remotely a chore, but it does require sweat and effort, both physical and mental. How hard you are willing to work is reflected in the finished photos. If you are willing to climb part way up a mountain, the reward may be a far more spectacular landscape than one shot at lower level.

For a professional, outdoor photography means taking chances, but it is such a challenging and exciting business that I would probably do so even if I were an amateur. Getting the pictures I wanted has meant suffering with everything from tsetse flies to seasickness. I once made the 25-mile crossing via vintage sailboat from Isla Cozumel to the Yucatan Coast, just to check out rumors of virgin fishing and lost Mayan ruins on the other side. It was a wild, nerve-shredding crossing as the sailboat wasn't really big enough to cross a large mill pond, let alone the tongue of an ocean.

Then there was the time in the bottom of a bottomless Utah Canyon, appropriately called Hell's Hole, where our pack of dogs had followed a sheep-killing black bear. It would have been better to stay on top and just listen to the hound dog music, but ranchers Ray Wilcox and Willis Butolph and I followed—Willis to keep track of his dogs, Ray because they were *his* dead sheep, and I to take pictures of the chase. Fine and dandy so far.

But down in the bottom, the hounds cornered the bruin against an under-cut creek bank and the melee which ensued was a savage, primitive spectacle. Fur flew. Dogs howled. As if by a magnet I was drawn in closer to get better pictures. That's when the bear thought I was one of the dogs and came after me. Except that the other dogs piled on, I might have another profession today. Like fertilizing daisies.

Outdoor photography—serious outdoor photography, at least—can mean

sudden dunkings in cold water as well as suffering in blazing heat. One dunking I can recall must be blamed on Bill Browning who thought that we would have a helluva story if we could chute through Beartrap Canyon of the Madison River on a rubber raft and emerge intact at the other end. I thought it was a good idea, too, until we approached the first rapids. Only rapids isn't the word for it. But by then it was too late to turn back. We were sucked furiously through the complete distance of the Canyon and somehow en route, before one camera was doused, I managed to take pictures of the sucking.

But perhaps there's good in every experience. At least the Beartrap trip taught me a few things about keeping photo equipment dry in similar situations. It was an expensive lesson, to be sure, but valuable in the long run.

Thanks to my vocation, I know what it's like to be lost, hopelessly lost. One time occurred in Africa when I became completely absorbed in getting photos of a fine bull kudu by following the critter through thornbush and wait-a-bits which clutched at my clothing. This time I didn't get many pictures of value and when the kudu finally spooked for keeps, I suddenly realized I hadn't the slightest idea where I was. Rather than walk and get lost farther, I simply sat down.

It worked. But I began to have doubts. There are better places to siwash out overnight than the Tanganyika bush. An hour or two later a savage face, grinning hungrily, peeked through the bush and said "Jambo." Fortunately jambo means hello and the face belonged to a remarkable Wanderobo tracker employed by our party. Some Wanderobos, it happens, can track men or animals with more skill than the best bloodhounds. This one tracked me.

I have also been lost on the opposite end of the earth from Tanganyika— in Alaska's unhospitable Chugach Mountains. This time I wasn't alone, but became far more miserable when a cold drizzle turned to sleet as night fell. Completely without shelter, I didn't see how Lloyd Bonner and I would be able to stay dry, let alone warm, and it seemed inevitable that I would have an insurance claim on a water-logged camera.

There was only one humorous incident that cold, unhappy night. Cramped and stiff from lying on the cold ground, I stood up to stretch. That's when I heard Lloyd talking in his sleep. "Come back to bed, Honey," he sighed, "I'm cold."

But you can quickly forget discomfort and misery when things suddenly break right. Next morning, after locating the thin trail to our spike camp, I felt tremendously exhilarated as I looked at four white Dall rams in my ground glass. And they looked back at me just long enough to get the photos I wanted. Then and there the earlier hardships of the expedition were forgotten.

Bob Richards, a Columbus, Ohio attorney and globe-trotting sportsman, is one of the very best examples of forgetting about hardships. Not long ago he made a two weeks long polar bear hunt which was truly an ordeal from beginning to end and it's well to relate the details here.

The hunt departed by cod fishing boat from a port on the extreme north coast of Norway. The idea was to cruise northward to the icy fingers of Arctic islands and to probe around the ice floes, always watching for the great white bears. But even at best the Arctic seas are angry and rough and on this trip they were constantly raging. Besides that, codfish boats have a yawing motion which is deadly. One member of the party never really recovered from the seasickness which he developed a short distance out of port. It simply wasn't a pleasure cruise.

But all the while Bob Richards kept shooting pictures of everything. He is a busy type of outdoor photographer as well as an extremely good one. And the photos of this trip show all the thrills and drama the hunters experienced—both with the sea and with the bears. Nowadays, when Bob shows his polar bear pictures to friends and neighbors, you would never know from the happy smile on his face that it was no Sunday school picnic. Bob will be able to enjoy that trip as long as he owns a slide projector and a screen.

Naturalist-cameraman Karl Maslowski, about whom we will say more later, is convinced that it's impossible to even sit in a blind without having the improbable occur. Of course the fact that his blinds are often in treetops or encircled by poison ivy vines may have something to do with it.

But on one particular occasion, Karl's blind was located merely beside a tiny waterhole in Arizona where he hoped to film the jackrabbits and quail which visited there. However, it was a very warm afternoon and when neither of these creatures appeared, Karl dozed.

How long he dozed he doesn't know. But suddenly he woke up, and at the same time had a feeling that he wasn't alone any more. And no wonder. Curled up between his feet and coiled loosely over one shoe top was a fat prairie rattlesnake.

Luckily Karl was both calm and familiar with the ways of rattlers. He didn't react violently and push any panic buttons. He figured the snake had only come into the blind to find shade . . . so slowly and without sudden movement he relinquished the blind.

Once outside the blind he muttered (to himself) something like "What a helluva way to make a living." Seems like I've heard that somewhere before.

No matter how you look at it, however, outdoor photography is a vocation or avocation that is always stimulating—and the unexpected is often likely to happen. Keep carrying a camera whenever you go into the field and see for yourself.

Selecting a camera can be a bewildering experience. So many makes and models are currently available that any outdoorsman (especially the man just getting interested in photography) might well wonder what kind of camera is best for him. But this very abundance of cameras can work in a sportsman's favor. It means he can have precisely the camera he needs at the price he can afford.

What is best for today's outdoor photographer?

First, he needs a camera which is convenient to carry. It should not be too heavy or too bulky. Second, it should be sturdy and reliable, able to with-

stand abuse and rough handling, and it should function in cold weather as well as in warm weather. Finally, the camera should be capable of taking pictures which will satisfy the user and make him proud of his work.

But before pursuing the matter in greater detail, let's examine a basic camera and see how it works.

Any camera (except the simple pinhole or vintage box cameras) is a light-proof box or housing with five main parts. These are (1) the lens, (2) the diaphragm, (3) the shutter, (4) a film-holding or winding mechanism, and (5) the viewing device.

THE LENS

The most important part of the camera is the lens. The quality of your pictures is limited by the capability of your lens, and the price of most cameras reflects the quality of the lens. The lens "sees" the same subject you see in your view-finder and then projects the subject onto your film.

No doubt you have heard of slow and fast lenses—or the "speed" of lenses. Speed in this case means the ability of a lens to collect and transmit light rays. The speed of a lens is determined by the diameter of the lens in relation to its focal length. For example, a lens one inch in diameter with a focal length of three inches would be an f/3 lens (one divided into three equals three). If the lens were a half-inch in diameter, with the same focal length, it would be an f/6 lens (a half-inch divided into three equals six).

On the most inexpensive and simple lenses, the speed isn't necessarily indicated. But on better or more complex lenses, the maximum speed is indicated with an "f" number—for example, f/2 or f/3.5 or f/8. The lower the f/number, the faster the lens, and the more light it can collect and deliver to the film. To give you a better idea of comparative lens speeds, an f/2 lens is four times as fast as an f/4 lens; the same f/2 lens is sixteen times as fast as an f/8 lens. Thus, the f/2 lens can take pictures under very poor light conditions which would be impossible for the slower lenses.

Time was when photographers had to wait for bright sunshine before they would dare begin to shoot. Modern fast lenses make photographing possible in any kind of light. Faster lenses also make it possible to use faster shutter speeds and therefore to shoot action pictures without blurring.

Besides differences in speed, lenses also differ in how sharply they transmit an image to the film. Although speed can be stated numerically (as f/4), sharpness is not stated. Some lenses have it, some do not. And other things being equal, the more you pay for a lens, the sharper it will be. However, all medium-priced lenses will be satisfactory for most amateurs. Only the professional or the scientists will need the very best (and most expensive) lenses.

Except on the simplest cameras, lenses must be focused to obtain the clearest possible image. Focusing is a matter of moving the lens (by mechanical means, usually coupled with the viewer or range finder) closer or farther away from the film. Ordinarily a lens also includes a footage-scale or zone-focus adjustment. The footage-scale can be set to match the distance of the

subject from the camera. The zone-focus adjustment is calibrated according to portrait, group, and scenic pictures.

The selective focusing possible with a good modern lens is a wonderfully handy thing for outdoor photographers. With this it's possible to accentuate certain objects and at the same time to de-emphasize or almost eliminate others. But more on this later.

THE SHUTTER

The shutter is the device which permits a burst of light to pass through the lens and the diaphragm opening when the release button or mechanism is tripped. On very simple and inexpensive cameras, shutters are factory-set at about 1/50 or 1/60 second. On others, the shutter speed can be selected and the choice will range from one second to 1/250 or 1/400. Still other cameras will offer shutter speeds as fast as 1/2000 second.

The shutters of most quality cameras also have settings marked T and B— to indicate Time and Bulb. When set on T, the shutter opens when the release is pressed and stays open until the release is pressed a second time. On B, the shutter remains open only as long as the release is being pressed. These settings permit picture-taking in extremely poor light or in special situations which we will consider later.

Shutters of most modern cameras have built-in synchronization for flash units. Some also have built-in self-timers or delayed shutters so that the photographer can make his settings and get in the picture himself. The advantage of this device to sportsmen is easy to understand.

THE DIAPHRAGM

We pointed out how each and every lens can permit a certain amount of light to pass through it. But the camera's diaphragm is the device which regulates *how much* of this light is permitted to reach the film for each picture. It is similar in principle to a valve in a pipeline: When the valve is

Three types of shutters: At left, between-lens leaf shutter allows automatic exposure in single lens reflex camera plus full flash synch, but does not permit lens interchangeability. Behind-lens leaf shutter, center, permits limited lens interchangeability, is adaptable to automatic exposure control and flash synch. At right, focal-plane shutter gives full lens interchangeability, but limits flash synch to low shutter speeds.

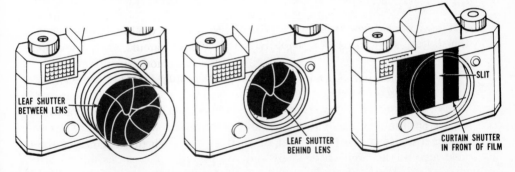

LEAF SHUTTER
BETWEEN LENS

LEAF SHUTTER
BEHIND LENS

SLIT

CURTAIN SHUTTER
IN FRONT OF FILM

wide open, ten gallons of liquid per minute may pass through; the further it is closed, the less liquid gets through, and the longer it takes the same ten gallons to pass. Similarly, the larger the diaphragm opening, the more light passes through the lens when the shutter opens and closes.

Diaphragm openings are known by various names—*lens opening, lens stop, f/opening, f/stop* and *f/number.* The reason these diaphragm openings are called f/stops or f/openings is because they are marked or identified with f/numbers—*the same f/numbers we used in discussing the speeds of lenses.*

For example, the f/2 lens on one of my cameras has diaphragm openings marked f/2, f/2.8, f/4, f/5.6, f/8, f/11, f/16, and f/22. The amount of light is regulated by changing from one of these to another, from maximum light at f/2 to minimum light at f/22. The intervals between these f/numbers on my lens (or on almost any lens) are called full stops because f/2 is twice as fast (admits twice as much light) as f/2.8, and f/8 admits twice as much light as f/11, and so on. On many cameras, it is possible to set the diaphragm opening at half stops—or half way between the full stops—for more exact exposures.

This is a good place to approach the matter of exposures, at least briefly. Since f/8 permits twice as much light to reach the film as f/11, a picture of a stationary object taken at f/8 with a shutter speed of 1/100 second will have the same exposure as if taken at f/11 and 1/50 second. This is because 1/50 second allows light to penetrate twice as long as 1/100, and it thereby compensates for f/11 passing only half as much light as f/8. If that seems confusing at first, read it again and write it down.

Now, look at it again another way: f/11 at 1/50 second *equals* f/8 at 1/100 *equals* f/5.6 at 1/200 *equals* f/4 at 1/400 etc., etc. The total amount of light received by the film is the same, whether it is a bright light for a short period of time, or a dim light for a longer time. It is just like filling a bucket with a large stream of water in a short time, or with a thin stream of water for a much longer time.

Another function of the diaphragm, in conjunction with the lens, is to control depth of field. This is the distance in front of and behind the subject within which all objects are in focus. The *larger* the f/number (which means, of course, the smaller the diaphragm opening) the *greater* the depth of field.

THE VIEWER

The viewer or view-finder frames the picture you will get when you release the shutter. It is where you actually compose your picture and adjust the focus.

There are exceptions, such as the focal-plane ground-glass viewers on very large commercial cameras, but most viewers today are divided into two categories—waist-level viewers and eye-level viewers. You hold a camera with an eye-level viewer up to your face and place your eye against the viewer. A camera with a waist-level viewer, such as a twin-lens reflex camera, is held against the stomach or chest and the photographer looks down into

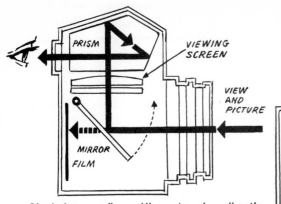

Single-lens reflex: View travels directly through lens to mirror, up through prism to eye at viewfinder. When shutter release is pressed, mirror raises, allowing view to reach film.

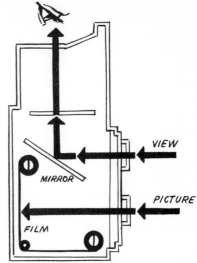

Twin-lens reflex: View passes through top lens to mirror and up to eye. As you take photo, shutter opens to let light pass through bottom lens and view is recorded on film.

Range-finder 35mm: View passes through rangefinder and reaches eye through viewer. As you focus until image is not distorted, lens is focused also. When shutter opens, view passes through lens to film.

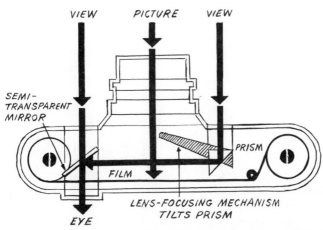

How range finder works (shown from above): Openings at left and right both let in a view of the subject, and the two views are joined before they reach the eye. As you focus, prism in range finder moves, affecting clarity of what you see. When combined view becomes undistorted, lens is also in focus.

the viewer. Photographers who wear glasses tend to prefer this chest type of viewer, which is shielded by a folding hood to eliminate bright light and reflections on the viewer. Some have a magnifier that can be swung into place for a larger image. Many single-lens reflex cameras have an eye-level prism finder sealed to keep out dust and dirt. For chest-level or waist-level photography they have an accessory right-angle finder that screws onto the eyepiece. Some models have a removable prism that is replaced by a simple hood and magnifier for chest- or waist-level use.

Sometimes open-frame or sports-type viewers are added as accessories to cameras. These are used for capturing action which could come from any direction. They're handy because they permit a cameraman to see what is beyond the picture he is composing.

In the many new automatic cameras with electric eyes, warning devices are incorporated into the viewers. Usually colored red or orange, these signal the photographer that there is not enough light to take a picture at that particular time.

THE FILM-HOLDING DEVICE

The last main ingredient of every camera is the film-holding or winding mechanism. In most cameras this is a system of rollers which moves a roll of film, section by section, behind the lens, holding it in the proper position when the shutter is released to take a picture. After the last exposure, the film is wound up and removed.

Many film mechanisms also serve as safety devices and automatically cock the shutter for the next picture. Most film winders insure against exposing the same frame of film a second time, thereby causing a double exposure. All these mechanisms also include "windows" or counters to show how many pictures have been taken and how many more remain in the camera.

Most outdoorsmen use cameras that require roll film rather than those that use sheet film or film packs. Cameras that use sheet film or film packs are usually too big and bulky for most outdoor use.

SELECTING A CAMERA

Now that we have described the workings of modern cameras, let us consider the best choice for the outdoorsman. That depends a great deal on how you answer the following questions:

1. What kind of adventures do you anticipate? Do you really get out and go—afoot, afloat, or on horseback—or are you a car-and-close-to-the-highway outdoorsman? Do you fish mostly from a boat or by wading?

2. What kind of pictures do you want? Color slides for projection viewing? Or black/white prints for album viewing? Or both?

3. How serious are you about taking pictures?

4. How much money do you want to spend?

Both bulk and weight are most important to the outdoorsman, especially if he is very active. Lugging a heavy camera around the neck, in a coat, on a backpack, or over portages can get to be a nuisance after a while. On the

other hand a larger camera—even a heavy view-type camera—can make superb landscape photos which will be a pleasure to see ever after. Color shots made with large cameras can often be more readily sold by the outdoorsman who entertains ideas of becoming a professional. But the cameras are quite expensive and so is the film.

Let's begin with the smallest cameras and discuss the values, advantages, and disadvantages of each as we work upward in size.

Miniature Cameras

There are a number of "miniatures" on the market today—cameras that can fit into a shirt pocket. Some of these are precision pieces of equipment which take passable pictures. For outdoorsmen the tiny size and negligible weight are good points, but still they are mainly novelty items. They use

The Kodak Instamatic X-90 loads with a cartridge that merely drops into place. A unique feature of the "X" line of Instamatic cameras is that they take flash pictures without batteries. A special Magicube inserted on top of the camera contains four flash bulbs, which are set off as you trip the shutter. The color shots of the pocket Instamatic shown can be projected in a special projector made by Eastman.

16mm film. Any outdoorsman is better off buying something larger—a 35 mm camera.

35mm Cameras

The 35mm cameras are the most widely used cameras in the world today. They are small, compact, and lightweight. Most 35mms measure no more than 6x3x3 inches, including the normal lens. Some models weigh as little as one pound and few models exceed two pounds. These are cameras taking a "full-frame" picture that measures about $1x1\frac{1}{2}$ on the film. These take twenty or thirty-six pictures on a roll. To avoid bulk, many new cameras either take a square picture (1x1), or a "half-frame" picture, about $1x\frac{3}{4}$. With the latter you get twice as many pictures—forty, or seventy-two—on a standard roll, and each picture costs only about half as much. There may still be some difficulty in having slides mounted in the half-frame size, though the popularity is growing rapidly and it won't be long before every major processor will mount them. A possible disadvantage is that these cameras usually take a vertical picture, instead of a horizontal one, when held normally. Most photographers should take more verticals than they do, and this is an excellent way to shake loose from stick-in-the-mud habits. These little cameras are perfectly capable of turning out excellent color slides, and, with a little care, excellent 8x10 black/white prints as well. They're a little more than half the weight of a full-frame "35," and about the size of a king-size pack of cigarettes. They're also comparatively inexpensive, as it is easier to make a small high-quality lens than a large one. These half-frame cameras are great for the sportsman who wants good pictures for his own use but doesn't want to lug any more gear than necessary. For professional or commercial purposes, though, you're better off with a full-frame 35mm camera or larger.

Virtually all 35mm cameras are built for maximum maneuverability and for fast, convenient shooting, with all controls at the photographer's fingertips. These cameras can take black/white negatives and color positive slides or color negatives. Most film processors return the black/white film negatives with $3\frac{1}{2}x5$ album prints, although prints of almost any size can be made from 35mm black/white negatives. Color film is ordinarily returned as transparencies mounted in 2x2 cardboard slides ready for projection on a screen or in a hand viewer.

There are actually scores of 35mms from which to choose. The outdoorsman whose interest is only casual, or whose budget is limited, will find some extremely good ones selling for less than $100. And although it isn't always true, these less expensive cameras also tend to be the most simple and least complicated to operate. And the simpler a camera is to operate, and the fewer settings you have to make, the better your chances are of getting a picture of a buck you've just spooked. If you're still fiddling with dials when he disappears over the ridge, you won't get anything at all. Better to have some sort of a picture, even if it isn't technically excellent, than none at all.

The simplified and self-setting cameras of the past few years can be depended on to turn out good pictures under a wide variety of conditions, with

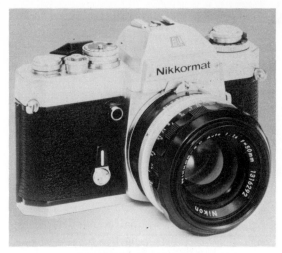

Nikkormat is an automatic exposure, 35mm, single-lens reflex camera, with metal focal-plane shutter. Set the camera to the desired aperture, and an electric eye automatically selects the correct shutter speed, depending upon the type of film in the camera. Self time allows photographer to get into picture himself.

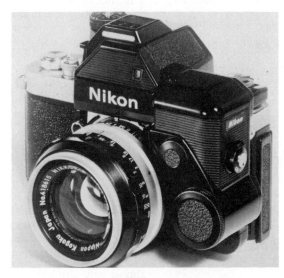

Nikon f/2 35 single-lens reflex camera, fitted with an electronic exposure-control accessory. It uses light-emitting diodes instead of a matched needle system to determine the correct exposure. Exposure control ranges from 8 seconds at f/1.4 to 1/2000 of a second at f/8.

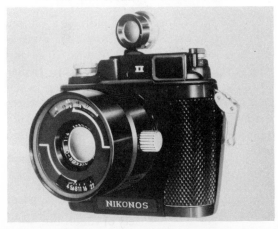

This Nikon is waterproof to a depth of 160 feet. It has an 80mm f/4 lens, interchangeable with three other lenses; focal-plane shutter with speeds ranging from 1/30 to 1/500 second.

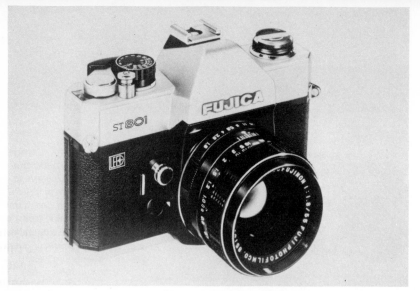

Fujica ST-801, a medium-priced 35mm, single-lens reflex camera that has a through-the-lens exposure system. The camera can yield a reading for the proper exposure in dim light. The shutter speeds, ranging up to 1/2000 of a second, are visible to the photographer in the viewfinder. Interchangeable lenses, from a wide-angle 28mm lens to a 1000mm telephoto lens, are available.

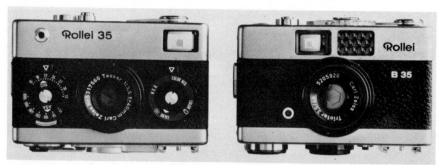

The small, compact Rollei 35 (left) has an f/3.5, 40mm Zeiss Tessar lens that retracts into the camera body. It has a CdS meter coupled by needle to aperture and shutter speeds, which range from 1/2 to 1/500. The Rollei B (right), is similar to the standard Rollei 35, except it has a less advanced lens, a selenium meter, and its shutter speeds range from 1/30 to 1/500.

practically no attention at all beyond quick aiming and pushing a button. Eastman Kodak, a few years ago, brought out a line of Instamatic cameras that don't even need film threading; you just drop in a film cartridge and the camera is ready to shoot, even setting its own exposure for that particular film! Some Instamatics can be wound up and will shoot ten pictures in ten seconds. These cameras are good for outdoorsmen; you can spend anywhere from $25 to $225, depending on how many features you need and how fancy you want to get. But make no mistake about it, high-quality outdoor photos can be made with 35mm cameras in the lower price ranges.

Reflex Cameras

Another possibility for the sportsman-photographer is the reflex type of camera. These have a tremendous advantage in that the photographer can

see exactly what sort of an image his lens is going to project onto the film; in other words, he can see precisely what his picture is going to look like when he trips the shutter. The 120-film-size cameras show a negative-size picture on a ground-glass viewfinder, 2¼x2¼, big enough for the most untrained photographer to do some composing before he takes the picture. These reflexes usually have two lenses, one for viewing and one for actually taking the picture, so there is a slight difference between what you see and what you get. If you always use the viewing lens wide open, it shows the minimum depth of field. Background objects may look very fuzzy in the finder, even when you shoot at f/22, but they will be sharp on the negative and print. The single-lens reflex avoids this by showing you exactly what you get, depth of field and all. The hitch is that at small apertures the image gets so dim you can't see it well or focus accurately. This problem is solved by automatic diaphragms that stay wide open until the shutter is released, then stop down for the exposure.

A twin-lens reflex is suitable under most conditions, but its big disadvantage is that, with one exception, you can't change lenses. You're struck with

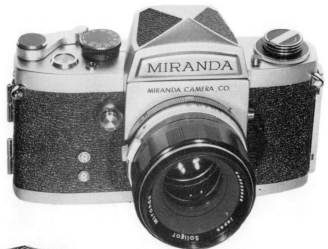

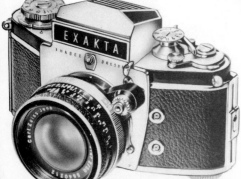

The popular Miranda and Exakta have automatic diaphragm, instant-return mirror, interchangeable lenses, and other features of fine single lens reflex cameras, each with special advantages for the outdoor photographer. Both are medium priced.

the normal lens, though you can lengthen or shorten it a little by using attachments. The one interchangeable-lens twin-lens reflex is the Mamiyaflex, in which you put on *pairs* of lenses for wide-angle or telephoto shots. This works just fine, for it is a high-quality machine. It will also focus very close, which is a lot of fun with small wildflowers, insects, and so forth.

The 120-film-size single-lens reflexes are expensive and complicated to make, and there are only a few around. The Hasselblad is the oldest and best-established, and the Praktisix has some good lenses to offer. So—one from Sweden, one from Japan, and one from Germany—take your choice. Other makes are the Honeywell Pentax; the Graflex Norita; the Rolleiflex and the Mamiya RB 67. They are all in the professional's price range. The 35mm SLR will do almost anything the larger camera will do, as far as the average photographer is concerned, and often more.

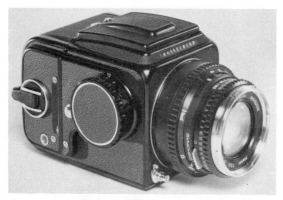

Newest model Hasselblad (above), the 500 C/M is a single-lens reflex camera with an 80 f/3.5 lens. Camera can be purchased with black trim (shown) or with brushed chromium; has interchangeable lenses, film magazines, view finders and focusing screens. The Hasselblad below is set up with a telephoto lens in a blind for photographing birds.

With any waist-level reflex, the image of an object moving from left to right moves from right to left on the ground glass. This can drive you to distraction when you're trying to follow a moving bird or animal—you have to shove the camera toward his tail. Put on an eye-level prism (which is available for almost all cameras) and you can swing the camera just like a shotgun. The percentage of "hits" gets better.

The 35mm single-lens reflex is a versatile and inexpensive camera for pro and amateur alike. Because it is a popular style, manufacturers make money by producing good ones, and competition leads them to develop better and better cameras with more useful features.

Press Cameras

Beyond the 120 reflexes come the larger cameras which have been variously labeled as press cameras, studio cameras, etc. These run the gamut from moderately priced to very expensive, and extraordinary outdoor photography is possible with them. They use cut film (in sizes 2¼x3¼ to 8x10) in both color and black/white. The film is inserted into these cameras by means of film holders or film packs.

But in spite of the excellent results possible with these cameras, they are hardly suitable for the typical outdoorsman. They are too bulky (and so is a supply of film holders), too heavy, and the film is far too expensive for nonprofessionals.

Perhaps the future of photography is in the instant picture. You focus, snap, and have your picture immediately. Of course Polaroid and others have made that possible even now, in color as well as black/white, but the surface hasn't been scratched.

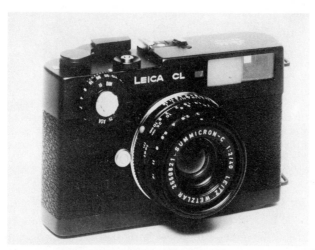

In the trend toward pocket-size cameras, the Leica CL is a miniature, containing through-the-lens metering system with film speed range of 25-1600 ASA, and shutter speeds from 1/1000 to 1/2 second, and B.

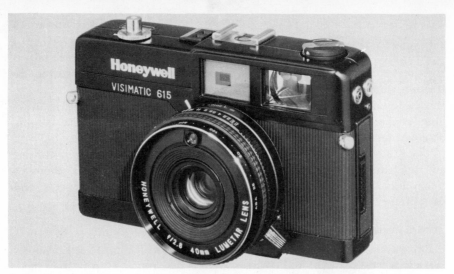

In the Honeywell Visamatic 615 a CdS sensor cell is coupled to an electronic shutter and an aperture-control circuit yielding shutter speeds from 4 seconds to 1/250. An amber light in the viewfinder indicates shutter speeds of less than 1/30, thus warning the sportsman that a tripod should be used.

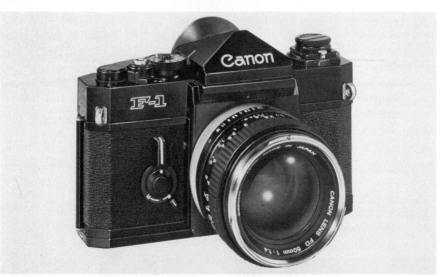

A black camera such as this type is recommended when shooting from a blind in order to minimize possible sunlight reflections that may scare off game and birds. This model, the Bell and Howell Canon F-1, can be equipped with an extra "fast" f/1.2 lens, suitable for taking pictures under very poor light conditions. Shutter speeds range from 1 to 1/2000 of a second.

Instant Picture Cameras

To be sure, the Polaroid system is useful to the outdoorsman. It is a grand way to photograph the man with his bragging-size fish or his first bull elk. On one of my trips, African natives were delighted to see their own pictures and responded by helping us find game. But the system has many drawbacks.

First, it is expensive. Color is almost prohibitive for anyone who wants to

The latest Polaroid camera is this unique SX-70, a folding reflex camera that can de-velop ten color pictures in 20 seconds. An electronic shutter automatically sets the correct exposure.

keep a detailed photo record of a trip. In addition, the photographer has neither the option of enlarging his black/whites nor of projecting color slides on a screen without complicated and expensive copying techniques which reduce the quality of his prints.

A few stereo cameras still linger on the markets after a boom in popularity some years ago. These use 35mm film and are made for home enjoyment of slides in hand-viewers which give a three-dimensional effect. We mention them here only for those outdoorsmen who want something completely different.

One more important point is worth making here before passing on to films, tripods, and other subjects: The camera is only the mechanical means of taking outdoor photos. Though technical quality depends largely on the film and camera, the pictorial quality of the finished photos depend on the man behind the camera.

Underwater Cameras

A number of good underwater 35mm cameras, which do not require ex-pensive housings, are available for sportsmen who snorkel or scuba dive. The price range is from $150 to $250 for the complete unit. One of these, the Ricoh, is complete with automatic underwater exposure meter and the film is advanced automatically by a windup mechanism. From 12 to 15 exposures are possible before it is necessary to rewind. When the camera is pre-focused correctly, it is only necessary for the snorkeler to aim and shoot. That is a great advantage for anyone without much experience underwater because it allows him to concentrate more on his swimming.

2 Film for Outdoors

NOWADAYS THE outdoor photographer has an extremely wide selection of films from which to choose, not only between color and black/white, but between films of different speeds and capabilities. Since film is constantly being changed and improved, and since new types are always being introduced, this discussion will have to be very general.

BLACK/WHITE FILMS

Today virtually all black/white films on the market are panchromatic— usually known as pan films. Panchromatic means that the film is sensitive to light of all colors. It renders human flesh, fish scales, foliage, or painted surfaces in pleasing tones, in different shades between pure white and solid black. In older, nonpanchromatic films, a red shirt on a hunter might show up as solid black. But if the black/white film is exposed properly today, the red shirt will have a plausible gray tone.

Besides being completely color sensitive, today's black/white film is faster and has greater latitude than ever before. This means there is greater allowance for error in exposure. The greater the latitude, the more you can miss the correct exposure (either underexpose or overexpose) and still have a good picture.

All pan films have certain characteristics in common, but there are differences. Some have more "grain" than others and some are more "contrasty." We'll take up both of these qualities later, but first will mention another difference—*speed*.

Any film's speed is the sensitivity of its emulsion to light. The more highly sensitive the emulsion, the faster the film—and consequently the less exposure needed. Faster, more sensitive film tends to be more grainy and to have more contrast than slower film. Grain, which shows up as a mottling or granular effect, is caused when particles of silver in the emulsion group together un-

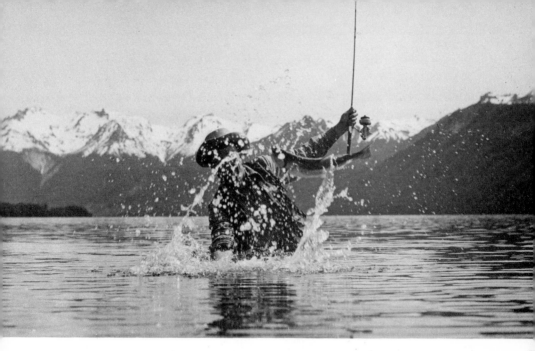

Fast films allow fast shutter speeds, which are necessary to stop rainbow trout and water in mid air, as shown above in Lago Traful, Argentina, and bobwhite quail, startling the Ohio hunter, below.

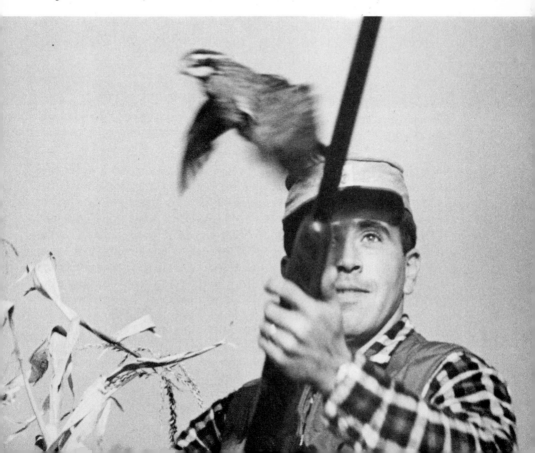

Early morning in a Reelfoot Lake, Tennessee, duck blind. The camera was hand-held at only 1/15 second and picture would have been impossible except for fast film.

evenly during development. Contrast is a film's ability to render a wide range of tones between black and white. In some picture-taking, high contrast is desirable; in most other cases it is undesirable.

The exact sensitivity of any film can be measured and every film is assigned a speed, or exposure index. It is stated either on the film's container or on an instruction sheet inside. Let us use Tri-X for an example because it is a fast, panchromatic, and popular black/white film in use today. Its officially rated speed is 400 and is generally stated as ASA 400. The ASA stands for American Standards Association, which governs and lays ground rules for such measurements. ASA ratings are accepted and in use around the world.

Compared to another black/white pan film with ASA 40 speed, Tri-X is ten times more sensitive to light and therefore ten times faster. In other words, the 40 speed film requires ten times more light (a difference of about three lens stops, or f/stops) to capture a scene on film, but the slower film will be less grainy and give less contrast.

Sometimes a film is given two exposure indexes—one for daylight or natural light and the other (often called tungsten exposure index) for such artificial light as flash, studio lamps, photofloods, and household electric bulbs. The indoor rating is usually about 20 per cent "less" than the outdoor speed.

If you use an exposure meter, it is absolutely necessary to know the ASA rating of your film. This number must be set on your meter before you make a light reading to obtain the proper exposure information.

CHOOSING THE RIGHT BLACK/WHITE FILM

Fast films often give best results in the hands of experienced or skilled photographers with adjustable cameras. They're excellent for the so-called candid pictures, perhaps of guides or friends afield, and for indoor use in camps, cabins, and around a campfire. Outdoors the fast films are necessary to stop action and to film scenes during bad weather. Manufacturers of fast black/white films do not recommend their use in simple, nonadjustable cameras.

Medium-speed films are for average outdoor situations, from fair to good weather. They are fast enough to capture most of the excitement of any outdoor adventure, and excellent for scenes and mood pictures. They are most

Fog and clouds caused poor light conditions when these sheep hunters were taken in Alaska's Chugach Mountains. Remedy was fast film, slow shutter speed and wide lens opening.

valuable for filming in a very bright environment—beaches, open plains or on clear days high in the mountains.

Slow-speed films have the least application for outdoor photographers. They are designed for photographers who plan to make extra-large enlargements, perhaps of spectacular scenes or of such tiny objects as insects or fishing flies.

Most of the time a photographer will get the best results by adhering closely to the film speeds given by the manufacturer. However, it is true that a particular camera or exposure meter may require some adjustment, and if good results come from using a higher or lower film speed, go ahead and use it.

The matter of developing black/white film will not be considered in this book, but one point must be emphasized. Just as the film speed is important in exposing the picture, proper development is equally important. In fact, exposure and development are interdependent. For best results, follow the manufacturer's instructions.

A properly exposed and developed black/white negative will have adequate over-all density—some transparent areas and some nearly opaque black areas. The transparent areas represent shadows; the opaque areas will become the highlights when the picture is printed. In between the two, on a good negative, will be a wide range of tones.

Underexposure results in a thin, nearly transparent negative without much density anywhere. Not much detail is apparent. The resulting prints are dark and muddy in appearance. To correct underexposure, either open up the lens by one or two f/stops or slow down the shutter speed—as from 1/100 to 1/50 second.

Overexposure yields a dense, dark negative with opaque areas so dark that no detail is visible in them. The resulting prints look washed out, faces appear chalky and sick. To correct consistent overexposure, close the lens aperture by one or two f/stops or increase the shutter speed—as from 1/100 to 1/200 second or even higher.

In the event of very bad light, or to capture (with a faster shutter speed) very fast action in good light, most black/white film can be exposed at more than its ASA rating—*IF* compensation is made in the developing. Assuming that you do your own developing, or have a custom photo-finisher, ASA 400 Tri-X can be exposed at 800 or even 1,000 without significant loss in negative quality. Consult development data which comes with every roll of film.

Let me emphasize, before passing on to color, that both overexposure and underexposure can be highly desirable on occasion when filming outdoors. In fact, a photographer may deliberately want to underexpose a picture— perhaps to give the illusion of night or darkness.

COLOR FILM

Many factors have contributed to the great interest in photography—such as the availability of fine, easy-to-use cameras—but the prime cause probably has been the perfection of reliable color film which has added a new dimen-

Brilliant sunshine made it possible to use slow film to capture smallest details in this scene in Costa Rica.

sion to picture-taking. Nobody has benefited more from color film than outdoor photographers because nothing is more colorful than the great outdoors.

There are two basic types of color film: One produces color negatives, from which both color and black/white prints can be made, and the other produces color positives, or slides.

A color negative reverses both colors and tones of the subject. Red becomes green, its complementary color; blue becomes yellow, etc. They cannot be projected as slides, but color positives can be made from them at additional expense. Ordinarily, color negative film is used by photographers who want color prints rather than slides.

Positive color transparencies retain all the natural colors and tones of the subject. They can be viewed by transmitted light, in a hand viewer or by projection onto a screen. Color prints can also be made from slides if desired.

Color films, or rather color emulsions, are usually slower than black/white films—although the trend is to produce faster and faster color films. Actually there are two basic types of positive emulsions: a daylight type meant to reproduce colors naturally in daylight, and an indoor type created for use with artificial light. Using indoor film in sunlight, or vice versa, produces off-color effects and should be avoided unless conversion filters are used.

Because most color film is slower than black/white, shooting is somewhat limited to brighter situations. There are exceptions, but the best results come from a bright, *even* light. I emphasize *even* because the contrast between objects or subjects in the light and those in shadow can be the bane of color photography. Color film is far less able than black/white to encompass the great range of brightness often found in a single scene. A good illustration of that might be a cowboy's face under a ten-gallon hat, partly in deep shadow and partly in bright desert sunlight. In cases like this, there is no correct exposure to cover both. But it is possible to use a reflector or flash to fill in the shadowed areas.

Where should a complete beginner begin in outdoor photography? What kind of film should he first buy—black/white or color? And why?

Black/white is considerably less expensive than color, both in initial cost and in processing, and is a good choice when you want to practice or get used to a new camera. Remember, however, that by the time you've made a print, black/white costs as much as color per shot, or more. Black/white film has more latitude and more tolerance of photographer-mistakes, and a beginner has a better chance of getting some sort of pictures instead of duds.

It is logical to suggest, then, that it is best to use black/white at least until the cameraman has had plenty of time to become used to his camera and to the basics of taking pictures. No matter whether he's using black/white or color, a beginner should be philosophical about his mistakes. He should consider practice film expendable, the same way a fisherman figures to lose some bait when he is in the process of learning to fish.

There are other reasons to choose between black/white and color. Subjects such as autumn's flaming foliage, the plumage of exotic birds, or an Everglades sunset simply demand the use of color. Black/white doesn't do such scenes justice. At the same time, it may not be worth the extra expense of color film to show the dreariness of a camp in the rain or the details of filleting fish or tying drab-colored flies.

Don't form the habit, though, of not taking any pictures in color except when the sun is shining and the subject is wildly colorful. Soft, pastel colors or the gentle light of an overcast day can be a very effective change from the smack-you-in-the-eye reds and yellows many people plop into every color picture. Avoid long shots in the rain or under overcast skys. Try for an area of flesh or some warm color fairly close to the camera. A close-up of your buddy fishing in the rain, with water running off his nose, can be a great color shot if you're close enough.

Some color films can also be exposed beyond their normal ASA rating when compensation is made in the development. One example is ASA 160 High

Speed Ektachrome. If sent to one of the Eastman laboratories and each roll marked accordingly, this film can be exposed at ASA 400. There is an additional developing cost of $1 per roll.

THE PROBLEM OF EXPOSURE

No matter what the film in any camera, there is *always* the matter of proper exposure to consider. In some modern cameras with automatic exposure meters, the worry about exposure is reduced to a minimum. You focus, aim, and shoot. However, these devices cannot always compensate for the contrasts between light and dark objects in the same scene, as we mentioned before. The meter can't decide whether the foreground or the background is more important to you, and if one is in the shade and one in the bright sun you may have some exposure error. Reflected-light meters always respond to the brightest area in a scene; but in practice you very seldom lose a picture. With some cameras (even though they have automatic exposure control) you can fool the built-in light meter. Get close to the subject and point the camera to the most important part. Press the shutter release button *slightly*—not hard enough to trip the shutter. This will lock the camera meter to the correct exposure. Now move back and trip the shutter.

An alternative to an automatic camera is to carry a separate exposure meter (see Chapter 3) and to "read" the light on both bright and dark areas. After that you can expose for whichever—light or dark—deserves the emphasis in your picture.

But there is still another, more effective way to arrive at proper exposure, and it is the one I nearly always use, unprofessional as it may seem. In every box of film, color or black/white, is an instruction sheet. This sheet contains such information as the film's speed, flash exposure guide numbers, filter data, and directions for development. Perhaps most important of all, it also contains an outdoor exposure guide for average subjects.

To be specific, this guide gives you the approximate exposure to use with that particular film—during (1) bright or hazy sun with distinct shadows; (2) cloudy bright with no shadows; (3) moderate overcast; (4) heavy overcast; and (5) in open shade. The exposures are figured to be correct when the light comes from over the cameraman's shoulder, but there are always instructions on how to compensate for side-lighting or back-lighting.

I'd like to repeat this point: If you follow the guide on the film instruction sheet, you will never be far from the correct exposure. Usually you will hit it exactly. If the picture is especially important to you, consult the instruction sheet and then bracket the exposure on each side of the suggested exposure. Do this by taking one picture with the recommended exposure; then open up the lens one stop, take a second picture, and close the lens down one stop for a third exposure. This way you are certain to get the photo you want. Sometimes the two "incorrect" exposures may prove more exciting or dramatic than the correct exposure.

If you use the same film day after day, you soon memorize the correct camera settings without referring to the instruction sheet. One cameraman

we know cuts the exposure guide from the instruction sheet and then tapes it to the back of his camera where it becomes an instant, fingertip reference.

All this is not to debunk the use of exposure meters; far, far from it. The poorer the light, the more important a meter becomes because the intensity of poor light is difficult to judge with the naked eye.

TWELVE TIPS ON HANDLING FILM

1. Double-check to be certain you have purchased the right size film. It can be tragic for an outdoorsman to take the trip of a lifetime only to find he arrives at a remote destination with film which will not fit his camera.

2. Find a film which gives good results—then stick with it. Experimenting, especially with new films, can be fun, but the most consistent results come from using a completely familiar film in which you have confidence.

3. Double-check the *type* of color film you buy—whether negative or positive, outdoor (daylight) or indoor (tungsten). Be sure you have what you want and need.

4. Beware of bargain film sales. You may be getting something that was salvaged from a fire or that is too old to be good. Check the expiration date on every film package. It is good advice to buy film where sales and turnover are good, rather than in shops where film may lie on shelves for a long time.

5. Keep film cool and dry; this applies particularly to color film. Never store it in hot places—around furnaces, heating pipes, chimneys, glove compartments, or the rear window shelf of a car. Avoid leaving film in the bright sun. On trips, roll your film up in a sleeping bag or jacket. When everything is cool—late at night or first thing in the morning—the insulation will help keep it cool, as long as it's not opened. Film can best be stored in a refrigerator, if one is available, but it must be vapor-sealed first or it will collect more moisture than is good for it. Wrapping it tightly in Saran wrap or aluminum foil with the seams taped shut is the best method. Let the film reach "room" temperature before loading to prevent possible moisture condensation on the surface of the film.

6. Always load or unload cameras in subdued light. If no other shade is available, as on a beach or desert, unload in the shade of your body. If you are in doubt when unloading an especially valuable roll of film, do so in a darkroom, or at least the darkest place you can find.

7. Be careful with filters. A common mistake is to leave a filter designed for black/white in place when shooting color.

8. It is foolish to leave a roll of film in a camera for a long time just because a couple of exposures remain. That's a good way to lose the entire role. Right after a trip, get all film developed immediately, particularly the color film.

9. Carrying several different kinds of film (of different speeds) on a trip can cause exposure mishaps unless you are always alert. If you carry two cameras, put a piece of tape on the camera and write in big letters with a felt-point pen what kind of film is in it.

10. Carry more film than you figure you'll need, especially on long trips

or important adventures. To run out of film when fishing reaches a peak is a sad experience. Film made in the United States may be scarce and is always more expensive in other countries.

11. It may seem perfectly obvious, but be certain to load film correctly in your camera. Failure to do so means *no* pictures. If you have any doubt about this, check your camera manual. Form the habit, when shooting, of watching the rewind knob while you advance the film. Assuming slack in the film spool has been taken up, if this knob doesn't turn backward when you wind the camera, the film isn't going through and you're not getting any pictures. Cultivate this habit until it is second nature.

12. Avoid cut-rate or drug-store photo finishing. Either develop films yourself or find a reputable, skilled photo finisher, even if he is more expensive. An astronomical number of good pictures have been completely ruined in the cut-rate darkrooms. With color film, send it back to the manufacturer for processing. He knows more about it than anyone else. Don't gamble with your whole trip's shoot at this stage of the game; it's just not worth it.

3 Photo Accessories

OF ALL the hobbyists on earth, none is more gadget conscious than outdoorsmen and photographers. Fishermen have gadgets for everything from locating fish electronically to unhooking them. And photographers have devices which allow a jumping fish to photograph itself! It's a gadget-filled world in which the outdoor photographer thrives.

But just as a fisherman is often inclined to be preoccupied with gadgets, so can a photographer become so preoccupied with accessories that he never gets around to taking pictures. However, some accessories are highly important when taking pictures outdoors, and we will discuss these in some detail.

ADAPTER RING

A basic accessory is an adapter ring which fits over the lens mount. It is used to attach filters, lens shades, or close-up attachments to the lens. These rings are supplied in a variety of sizes (designated Series V, Series VI, etc.) and either the camera manual or your camera dealer can tell which size fits your camera.

LENS SHADE

Also called a lens hood or sunshade, a lens shade is a blackened hood which protects the lens from the direct rays of the sun when you take a photograph. It is an important accessory, especially outdoors in bright sun, because it can improve the clarity and general quality of all pictures. Unless you can actually shade the lens by another means (a hand, a hat, or the shadow of a tree), a lens shade *must* be used for side- and back-lighted scenes. Otherwise streaks or blotches of light will appear on the film.

FILTERS

Entire books have been written about photo filters and their use. And no wonder, because a few filters can greatly extend any photographer's ability to take more beautiful and striking pictures. That is particularly true in black/white photography, which we will consider first.

Filters are sheets of colored glass or gelatin which pass light of certain colors to the film while holding back other light. This is valuable to a black/white photographer because certain colors often appear different to the human eye than they do to photographic film.

A good example of this is the sky, an important ingredient in many outdoor pictures. A deep-blue sky and snowy-white clouds are assets to most scenic pictures. But the sky seldom appears as dark or the clouds as fleecy as they are, simple because black/white films are extremely sensitive to blue light and ultra-violet radiation, both of which are abundant in the sky. To the film, then, open blue sky and clouds look pretty much the same.

Of all the filters available to cameramen today, none is used more frequently than the filter that corrects this deficiency between clouds and sky. Add a yellow filter and the blue sky becomes light gray instead of white on film. Add an orange filter and the blue appears just about the way it does to the eye—or perhaps a little darker. Clamp a red filter over the lens and the sky becomes dramatically dark, but trees and foliage are darkened as well.

One problem common to many outdoor black/white photographers is that foliage and vegetation turn too dark, ruining what otherwise might have been a good photograph. The remedy here is a green filter, which accomplishes three things: it produces lighter-colored foliage, it slightly darkens the sky, and it gives particularly pleasant flesh tones.

Filters aren't nearly as important when using color as with black/white, and many busy outdoor photographers never use them. However, there are various "skylight," haze, Pola-screen, diffusion, and conversion filters available, each for a specific purpose.

Skylight filters are offered to correct the slight color errors in certain color films. Occasionally their use is described on the instruction sheets with each roll of film. A Pola-screen filter is nearly colorless; it specializes in darkening skies and erasing bright reflections without affecting the colors in a film. However, this polarizing effect is at a maximum only when the sun is at right angles to the subject. Very interesting and often unusual shots are possible with Pola-screen filters. Remember, every polarizing-filter shot needn't be at the maximum amount of "correction." Try darkening the sky just a little, instead of as much as possible. Most people overdo it.

A diffusion filter gives any scene a soft, hazy, diffused look which isn't exactly natural but which at times has great pictorial interest. Conversion filters are sold to permit using daylight color with artificial light and vice versa. But it is best to use the correct film in the first place if you can.

The use of filters usually requires increasing the exposure—with some filters only slightly and with others by several f/stops. The degree of exposure increase necessary is called the filter factor. First find the filter factor of the

filter you're using; then multiply the exposure by the factor number. If the correct exposure is f/11 at 1/100 second and the filter factor is 2, the new exposure using the filter will be either f/8 at 1/100 or f/11 at 1/50.

CLOSE-UP ATTACHMENTS

A close-up lens, close-up attachment, or extension tube for close-ups can open up a whole new world of fascinating detail to any outdoor cameraman. There are different types of attachments: some clamp onto the regular camera lens; some are sleeves or bellows which fit between camera and lens, etc. In any case, they accomplish roughly the same thing and are handy for off-season shooting at home (trout flies, fly tying, engraving on guns, flowers, trophies) as well as shooting extreme close-ups in the field (fish, flowers, lichens, sea shells).

A few words about using close-up devices. Exact, critical focus is important. The camera should be mounted on a tripod or another firm base. And with twin-lens cameras it will be necessary to correct for parallax. Extreme close-ups will require an adjustment in exposure, depending upon the degree of enlargement. More details on this subject will be found in Chapter 9.

EXPOSURE METERS

Photographers are fortunate these days in having a choice of so many fine exposure meters. Unlike the limited and fragile meters of many years ago, there are meters designed to handle every photographic situation—from measuring light of the moon to objects in the ocean depths.

Basically, today's meters are of two types: (1) selenium cell and (2) cadmium sulfide (CdS) cell. The selenium cell generates a tiny electrical current when

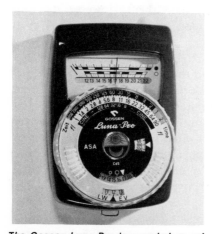

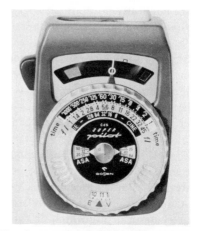

The Gossen Luna-Pro is a cadmium sulfide meter for reflected and incident light work. It embraces a viewing angle of 30 degrees and is calibrated for ASA film speed from 6 to 25,000; f-stops from f/1 to f/90, shutter speeds from 1/4000th to 8 hours. It is calibrated for use with motion picture cameras.

The Gossen Super-Pilot reads reflected or incident light. It is a CDS meter for use with films of ASA 6 to 12,500; f-stops from f/1 to f/45; exposures from 1/1000 second to 2 hours. A special needle lock for low light readings is built in the meter, as is a battery tester.

its light-sensitive surface is illuminated. The amount of current it generates depends upon how much light strikes the cell's surface. The CdS is not a light-powered source of current, like the selenium cell. Instead, it is arranged in series with a mercury battery and a rugged, comparatively inexpensive direct-current milliammeter. The CdS cell acts as a light-controlled "valve." Current flowing through the cell is proportional to the light intensity illuminating the cell's light-sensitive top. Since the light is controlling current, not producing it, the smallest changes in light intensity can be measured. Typical CdS cells, therefore, are many, many times more sensitive than selenium cells at low light levels.

Both types of meters are accurate and dependable. Examples of meters that use either selenium cells or CdS cells are shown on these pages.

Exposure meters are used in one or both of two ways: measuring incident light and measuring reflected light. Both methods are highly useful and many cameras come with reflected light meters already attached.

Incident-light meters are held in front of the subject and pointed toward the camera. The reading which results indicates how much light is illuminating the subject. Reflected-light meters can be used by pointing the photoelectric cell toward the subject from a distance of about six inches. This gives a light reading for the particular local area at which the cell is aimed. By holding the cell farther from the subject, you get an "average" reading. After light readings are obtained, they are translated by various dials and settings to obtain the proper exposure.

A word of caution is necessary here. Either type of meter gives good results, but both require considerable skill in handling and the more experience in interpretation the better. Using an exposure meter alone is a complicated

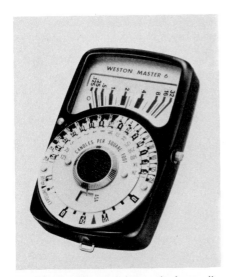

The Weston Master 6 is a selenium-cell meter. Excellent for accuracy and dependability, it has a needle lock for low light readings, and is lightweight too.

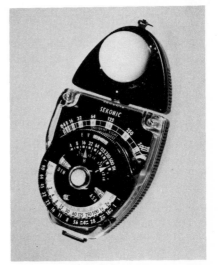

This Sekonic Studio Deluxe meter has interchangeable discs for incident and reflected light. Sekonic also makes an excellent underwater meter, good for depths up to 300 feet.

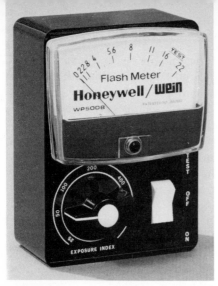

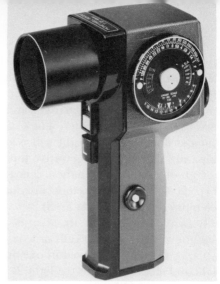

If you go in for a lot of electronic flash work—such as strobe lighting—it may be worth your while to invest in the flash meter shown here, a Honeywell/Wein Flash Meter. The meter is placed at the subject, not at the camera position, and interprets the burst of light into direct f-stops. A nine-volt battery (the kind used in transistor radios) powers the meter.

Late model Honeywell Pentax spot-reading meter gives a 21-degree angle of view on a ground glass. In the center of the viewing screen is a 1-degree circle which represents the angle covered by the meter's sensing element. This type of meter is extremely selective, thus permitting exact exposure readings at great distances. Its ASA range is from 6 to 6,400. It will indicate the correct exposure from four minutes to 1/4000 second.

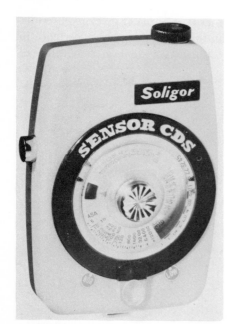

Clip-on meters are comparatively inexpensive. This Honeywell Pentax meter has a range of 6 to 1,600 ASA, a viewing angle of 30-degrees, and uses a small battery to power the cadmium sulfide sensor. It also has a test button to determine if the battery should be replaced.

A small, comparatively inexpensive pocket meter is the Soligor Sensor CDS. It measures reflected light, film speeds from ASA 5 to 12,000. A built-in beam limiter reduces the viewing angle from 30-degrees to 18-degrees.

skill which almost matches that of taking good pictures. Be certain you follow the meter manufacturer's directions to the letter.

Besides the more complicated photoelectric meters, several kinds of "poor man's meters" are available. These are pocket-size systems of cardboard dials which give the correct lens and shutter settings for a variety of light conditions and for different kinds of film. One side is devoted to color, the reverse to black/white. They sell for a dollar or less.

The most useful exposure meter I have ever found is the fairly expensive Soligor Spot-Sensor (about $100). It is a pistol grip meter with a one degree view which makes it possible to read (measure the light) of either highlights or shadows, of any surface. The value of such a meter is vastly increased in low light situations, as when the sun is directly overhead, in deep forests, or when shooting indoors with available light—in other words without flash or floodlights. This meter can be conveniently carried on the belt in a small pistol holster.

CARRYING EQUIPMENT

The best place to carry a camera for immediate use is around the neck. Far too many excellent outdoor pictures are missed because equipment is tucked away in a duffel bag. At the same time it is necessary to keep a camera free of dust, grit, snow, water, and particularly of salt spray which can cause the most lasting damage of all.

If you buy a case for the camera, the best is the one designed for the cam-

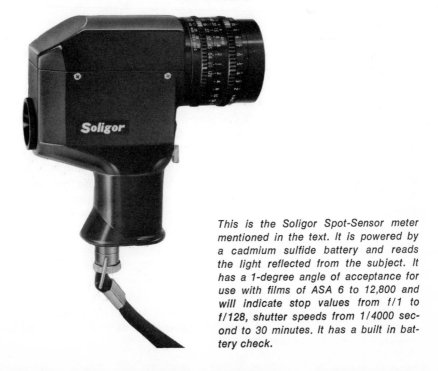

This is the Soligor Spot-Sensor meter mentioned in the text. It is powered by a cadmium sulfide battery and reads the light reflected from the subject. It has a 1-degree angle of acceptance for use with films of ASA 6 to 12,800 and will indicate stop values from f/1 to f/128, shutter speeds from 1/4000 second to 30 minutes. It has a built in battery check.

Simple two-button cloth flap on outside of jacket carries camera close to you, preventing its getting in the way, or knocked about.

era, even if it is one of the so-called ever-ready types which encase the camera except when you are loading or unloading film. But eventually, if you do much shooting, this kind of case only gets in the way. A disposable plastic bag is much better.

Because I am constantly traveling and photographing in widely varying situations, I use many different carrying cases or containers. When flying or traveling by car, my equipment goes inside sturdy, waterproof and dustproof aluminum luggage. Inside this are sheets of polyurethane foam which are cut out exactly to fit individual cameras and lenses. The foam is a cushion against rough handling and vibration. When flying, I do not check the aluminum case, but rather hand-carry it and place it under the seat. It is good advice to carry all film on your person (rather than checking it in other luggage) to avoid its exposure to X-ray and other searching devices now used on the commercial airlines.

Whenever on the water, my cameras and lenses go inside individual light plastic bags and, in turn, inside a waterproof rubber gadget bag. The best kind of bag I have found was originally designed by the military services for carrying field radios—and is available in most army surplus stores for a dollar or two. These have spared me countless times from sudden squalls and from waves washing over the side of a boat.

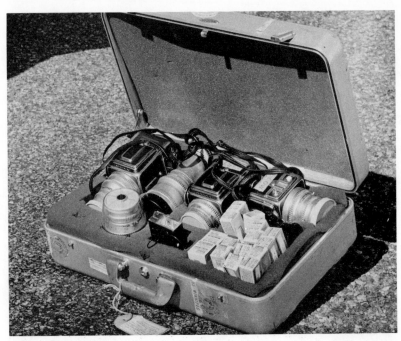

This waterproof, dustproof aluminum carrying case has polyurethane "pillows" to protect photography equipment.

Spot-sensor exposure meter is within handy reach in this holster outfit. It attaches to photographer's belt and can be zippered open for use.

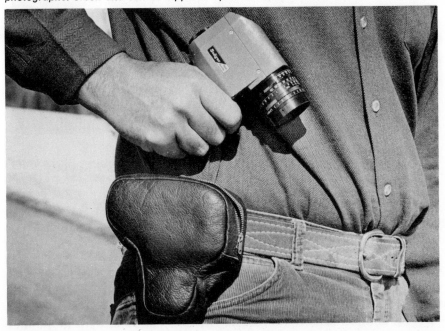

On pack trips, cameras go (again each in a plastic container) into saddle bags made especially to fit them. Foam, a sweater or loose cloth packed around the cameras will absorb some of the shock of riding a horse. When hiking, cameras and accessories go into a light nylon rucksack. Another handy method of carrying a camera is inside a belt or waist pack like the type used by cross-country skiers.

TRIPODS AND UNIPODS

A tripod provides a rock-steady base for shooting any kind of picture. It is used primarily when you are shooting in dim light at slow shutter speeds. Some sort of camera-holder is necessary if you're alone and want to use the

On many outdoor trips it is necessary to carefully pack and waterproof photo equipment. This is how author's photo gear and other provisions were packed for travelling on rugged Colorado River. Bag at right is made of rubberized material.

Custom-made saddle bags for carrying author's photo equipment on horseback can also be slung over one's shoulder when on foot, as shown opposite.

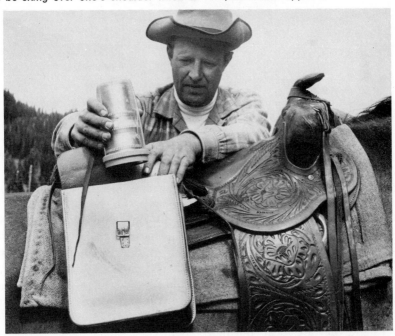

A skier's waist packet is another easily accessible holder, allowing freedom for both of user's hands, and keeping the camera close to the body.

camera's self-timer to take your own picture. The really meticulous photographer, of course, may want to use a tripod in every situation.

Buy any tripod carefully. The legs should telescope and the whole device should be sturdy even with legs fully extended. You should also be able to lock the legs securely in any position, at any elevation. The tripod should also contain a smooth-working pan-head which can be locked in any position.

Maybe unipods have some use afield, but considering the bother of carrying one, a tree or fencepost or rock is just as good. Camera steadiness can also be obtained by using a neck strap and holding the camera so that the strap is pulled tightly around your neck. The little device called a Clampod or Optipod is worth its weight—which is minimal. For the man who wants to travel light, they are ideal—but more about these later.

WIDE-ANGLE LENS

We often hear the terms "focal length" and "normal focal length." Focal length of any lens is the distance from the lens to the film when the lens is focused on infinity. A lens is of normal focal length for a given camera when the distance from lens to film is roughly equal to the diagonal of the negative.

Example: With 35mm film measuring 24 by 36 millimeters, the diagonal measures about 45 millimeters. Therefore the normal focal length for a 35mm camera would be about 45 millimeters. In most 35mms, however, a 50mm focal length is considered normal because its perspective is more nearly like that of the human eye. Telephoto lenses have a *longer* focal length than normal lenses, and wide-angle lenses have a *shorter* focal length.

Weird effects are possible with a wide-angle lens, though sometimes obtained inadvertently. However, these lenses have a number of important uses. Standing in the same spot, a wide-angle lens will cover a wider field than a normal lens. You have a better chance of getting action pictures of a friend catching a fish while you are both in the same boat. The wide angle compensates for the photographer's lack of room to back farther away from the subject.

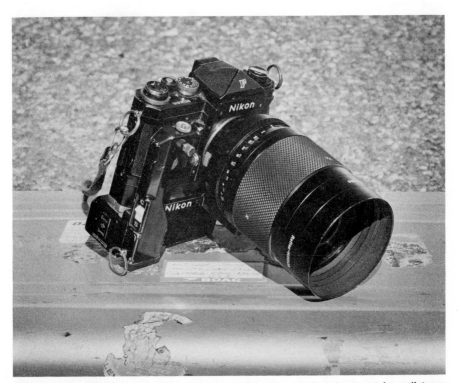

Motor-driven Nikon F with 500mm lens is outfit author prefers for most long-distance wildlife photography.

38mm wide-angle lens

80mm normal lens

120mm telephoto lens

150mm telephoto lens

250mm telephoto lens

500mm telephoto lens

Compare the focal lengths of these shots taken from the same position with a Hassel-blad 500C. The normal lens for this 2¼"-format camera is 80mm.

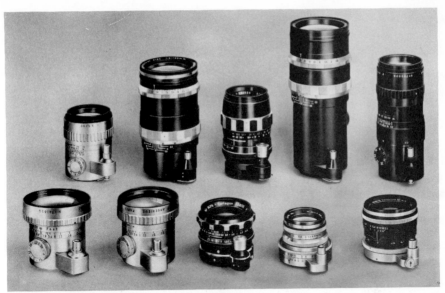

A typical system of lenses ranging from 24mm wide angle to 180mm telephoto available for one type of 35mm camera, the Alpa.

TELEPHOTO LENS

These are lenses with a longer than normal focal length. They magnify the size of the subject while transmitting it to the film. One obvious use for the telephoto lens is photographing wildlife too shy to be approached at close range. But it has many other uses. Telephotos are often better for scenics; they seem to "stack up" the many flat parts of a landscape and give it a depth which is impossible to achieve with lenses of shorter focal length. Often portraits are enhanced with a telephoto lens; because of its smaller depth of field, background can be eliminated and the portrait becomes more "alive." Also, people feel more relaxed when they are farther away from the camera, and candid pictures are more easily made.

Telephotos also have drawbacks. Generally they are slower and therefore limited to situations where the light is good. We have already mentioned that depth of field is smaller, and in some cases this can be a disadvantage. Also, subject movement is harder to arrest than with normal lenses. A relatively high shutter speed is always advisable when using a telephoto, to arrest subject movement and to minimize the effects of camera movement.

Telephoto lenses should be purchased with care and caution. The natural inclination of many outdoorsmen is to obtain an extremely long lens to film the wild creatures they are always encountering. Too often they do not take into consideration the limitations of the lens and the awkwardness of its use. It may not even be compatible with the camera for which it is intended. I repeat—proceed slowly when thinking about telephotos, especially the very long ones. If you are not an experienced photographer, it may be safest to

Mirror telephoto lenses allow you to get striking close-ups of distant wildlife. Such lenses fold light rays back and forth so that a long focal length is achieved in a comparatively short barrel. Most are "slow" lenses with "f" values ranging from f/4.5 to f/16, a focal length from 300 to 1000mm. This mirror lens has a focal length of 500mm and a fixed f/8 value.

stick to the telephotos designed by the manufacturer specifically for your camera.

RECENT ADVANCES IN TELEPHOTO LENSES

Some of the greatest advances in photographic equipment have been in telephoto lenses. Several years ago the pistol-grip, follow-focus lens was introduced by Novoflex. This permitted the cameraman to focus by squeezing or relaxing the grip, a decided improvement over twisting a focusing ring while trying to hold the outfit steady. After a little practice, the follow focus also became much faster.

Recently the mirror or reflex telephoto lens has come on the market. For the wildlife photographer, this design is certainly a boon. A reflecting mirror cuts the length, weight and bulk of a telephoto lens in half. For example, the Nikon 500mm mirror lens I now use measures $5\frac{1}{2}$ inches long and weighs 2 pounds. An older 500mm telephoto measured 14 inches and weighed $3\frac{3}{4}$ pounds.

Of course the mirror is easier and faster to operate. When hand-held, the shorter tube is not so subject to vibration or movement; it can be held much steadier. But there is still a minor handicap in mirror lenses to be considered. At present, the f-stop is fixed and the correct exposure can only be obtained by changing the shutter speed of the camera. For instance my 500mm Nikon has a fixed f/8 lens. Like all other telephotos, mirror lenses have a very small depth of field.

Mirror lenses today are available up to 1000m (f/11) in focal length. Their depth of field is extremely limited and a steady "rest" or sturdy tripod is absolutely necessary. For general field use, the 500mm is ideal and also the maximum focal length which is still easy to use. I do not hesitate to hand-hold the 500mm when a 1/500 or 1/1000 shutter speed is possible. When

photographing a slower speed, I try to use a rest both for focusing and picture-taking. Hopefully the next development in telephotos will be the mirror lens with adjustable f-stops.

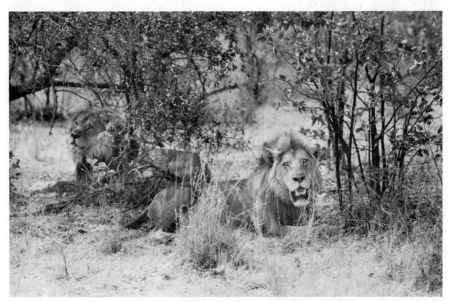

When photographing wildlife such as lions and rhinos, stay in your car. This is the advice offered by all professional game guides. Both of these pictures were taken with telephoto lenses and camera holders similar in design to a gunstock.

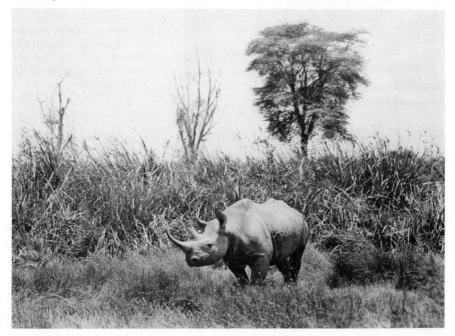

The author using a 640mm Novoflex lens on a Leica M3 to bring distant antelope up close. Novoflex allows focusing adjustment with trigger action of right hand. A lens of this size must be held absolutely steady, thus the use of car hood as support.

Leica with a 300mm lens and Visoflex housing mounted on a handsome gunstock for wildlife photography by Frank and John Craighead.

ZOOM LENSES

Another new development in telephotos is the zoom lens. Zooms have been available for motion picture cameras for some time, but only recently have very good ones been on the market for 35mm still cameras. These give a cameraman a choice of focal lengths, say from 35 to 100mm or from 90 to 230mm, all in the same tube. The obvious advantage of this is not having to carry along extra lenses or to interchange them. But a distinct disadvantage is in the extra weight of the zoom, the considerable cost and the fact that not all of these are critically sharp along their range.

Keep in mind, however, that the use of *any* kind of long focal length lens usually affects the exposure. Lenses of from 350mm to 500mm may have to be opened from one-half to a full f-stop for the exact correct exposure.

MOTOR DRIVES

Motor drives powered by small batteries are available for many of the better 35mm cameras and for the Hasselblad. These advance the film automatically and permit up to four or five exposures per second. Motor drives have two major drawbacks: they are heavy (as well as bulky) and they are expensive. But otherwise they are worth their weight in gold to the really serious outdoor photographer.

The value of being able to take several exposures per second is obvious: You are almost certain to catch the peak of any action you may be photographing—say a man skiing downhill, a marlin jumping, or an eagle landing on its treetop nest. But that is only the half of it. A motor-driven camera permits the photographer to concentrate on his subject and, particularly when it is moving, to maintain focus without having to bother advancing the film. Too often advancing film manually means "losing" a difficult subject, briefly, but at exactly the time you should be snapping the shutter again.

Some of the early motor drives were troublesome and unreliable. But mine, mounted on a Nikon F, has had constant use and rough handling for two years without missing a beat. Maybe I should knock on wood.

FLASH EQUIPMENT

Flash is often the first accessory a photographer wants to acquire. That's understandable, because here is another item which can expand his range. With artificial light he can photograph his companions inside camp or in a deep forest. He can also capture outdoor activities at night which otherwise would never get on film.

A number of modern cameras come with built-in miniature flash equipment. Do not underestimate what such a small unit can do. Nowadays a flashbulb no bigger than a peanut, with a fold-up reflector, can furnish all the light you may need.

Other cameras without built-in flash can be used with an accessory flash unit by synchronizing it with the shutter. Whether the flash is built-in or an accessory, you have greater control over the lighting for your pictures than if you must depend on natural illumination alone.

For each flash picture, you will need a fresh bulb. These come in different sizes (the larger, the more light they give) to fit different flashguns. But the gun you buy should be compatible with your camera, and it should be light as well as compact. If the manufacturer of your camera makes a flashgun to match, that is probably your best choice.

There are two kinds of bulbs—clear and blue. Clear bulbs are for use with black/white film, although blue bulbs will do in a pinch. The blues are made specifically for color film. Clear bulbs will usually give color photos or slides

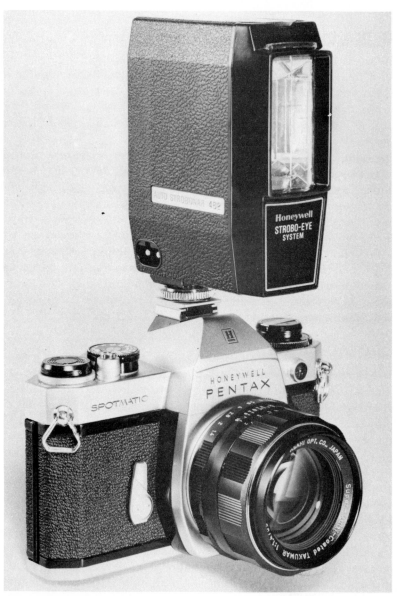

Some sort of flash accessory for your camera is desirable for lightening shadows and for taking pictures in poor light. The Honeywell Pentax camera is equipped with an electronic flash called the Strobo-Eye. A sensor built into the camera automatically controls the flash exposure.

a decidedly yellow tint. Always check the bulb you're using with your film to avoid disappointment later on.

It has often been stated that the use of flash is too troublesome to be worthwhile, but that certainly isn't true anymore. Most flash failures result from worn-out batteries. A fresh set of batteries might last for 100 shots or more, but toward the end they're not always dependable. The antidote is always to carry new, fresh batteries; or better still, use a BC (battery capacitor) flash unit. Pretty near fool-proof are the new Magicube flash bulbs which fire without any batteries. They are fired mechanically, somewhat on the order of striking a safety match.

An alternate to the flash unit is the speedlight or strobe light. These are heavier, bulkier, and more expensive, although some light, portable models have been introduced in recent years. The advantages of the strob unit include a fast, action-stopping flash (1/2,000th of a second and even faster). The portable units are powered by batteries; some can even be used with house current.

When using flash or speedlight, it may be difficult to find the correct exposure unless the film information sheet is consulted. This sheet gives complete exposure data (guide numbers for that particular film) when different-size bulbs are used at varying distances from the camera.

CABLE RELEASE

This is a minor, specialty accessory which can be screwed into some cameras. It permits tripping the shutter without jarring the camera, but you should train yourself to do this with the normal shutter button. Remember to *squeeze* it, rather than push or jab at it—just like shooting a target rifle. A long cable release permits the cameraman to shoot while standing some distance from the camera. This is good for photographing wildlife.

REFLECTORS

These can be extremely worthwhile in many outdoor situations. Best of all, they can be made by anyone in a home workshop at little expense. They're used to reflect or bounce sunlight into areas in shadow which would ordinarily photograph too dark. Single sheets of white cardboard are good reflectors at times; they will reflect a soft light on faces and animals. But somewhat better is to glue sheets of crinkled aluminum foil to a flat surface. These boards can be used to reflect artificial light as well as sunlight.

PROJECTOR AND SCREEN

These are necessities for the cameraman who specializes in color slides. Very good hand-operated projectors are available at surprisingly low cost. Automatic or finger-tip remote-control models are much more expensive. When buying, look them over carefully and select the best you can afford.

CLAMPOD

This is a gadget on which the camera can be mounted and which in turn

Night pictures like these (of cooky in a Montana deer camp, and landing tarpon near Isle of Pines, Cuba) add much pleasure and satisfaction to outdoor trips. All that's needed is a simple flash or speedlight attachment.

can be clamped to a firm, solid object. Some even have a corkscrew for attachment to any wood surface. In some instances it can take the place of a tripod. This device also permits a sportsman to take pictures of himself, providing the camera has a self-timer.

The outdoor photographer will also want to carry lens tissue and a camel's hair brush for keeping lenses clean, spare batteries, as well as spare magazines, slides, and film holders if his camera requires them.

Now—three rules of thumb concerning all camera accessories:

1. Be familiar with what a particular accessory can do for you before you buy it. Be certain you really have need for it.

2. Avoid accessories of lower quality than your camera—especially optics. It's far better in the long run to buy "up" instead of "down."

3. Get acquainted with your accessories and carry them where they're handy and ready to use.

4 Composing the Outdoor Photograph

MOST OUTDOOR photographers have to learn to "see" pictures. When studying a scene, perhaps of a magnificent mountain range, the naked eye doesn't see exactly what the camera sees. If the viewer enjoys seeing the mountain range, his eye will involuntarily skip over any ugliness in the foreground. He will not see the power lines or the unsightly billboards right in front of him. But these items will show up on film and the result is one of disappointment and even disbelief that all this ugliness existed in the first place.

All your pictures will be composed on your camera's ground glass or view-finder and eventually your eye will be abe to visualize every picture as if seen through a ground glass. I frequently find myself mentally evaluating a scene by how it would look in my camera's view-finder. Make the maximum use of your view-finder. At least for a while, to establish good picture-taking habits, consider the following points before taking every picture:

1. Look at the *entire* picture in the view-finder, rather than concentrating on the central area, or on the main subject, alone. Is there anything around the edges which is distracting and which should be eliminated?

2. How about the background? Can you get rid of unnecessary detail by changing the camera's position? Maybe you can throw unwanted background objects out of focus. Be certain that trees and poles do not grow out of the heads of your subjects.

3. Be certain the line of horizon is level.

4. The camera angle should not be tilted so much that objects appear deformed. This is a common failure among outdoor photographers when shooting trophy pictures. Frequently the antlers of animals are distorted out of proportion or the hand of an angler holding a fish will appear several times its normal size.

5. Check the four edges of the picture to be certain they do not cut off heads, wrists, feet, or other important parts of the subject.

All this calls for extra concentration at first, but soon you will do it quickly and without even thinking about it. And of course you will be getting better and better pictures of your outdoor adventures.

CENTER OF INTEREST

There are exceptions, it's true, but the very best pictures are simple. There should be one center of interest and one reason for shooting the picture. Let's take a typical fishing situation for an example. You are in the mountains with a friend who is wading waist-deep in a singing mountain stream. He's enjoying himself immensely. The entire setting is one of great beauty, and you would like to record it on film.

You reached this stream on horseback and, to add to the scene, you consider tying the horses to a sapling in the foreground. It *might* be a good idea, but chances are that it would only complicate rather than simplify an otherwise appealing scene. The horses would only detract from the main subject of the picture. Why not instead shoot a second picture of your companion riding his horse up a steep trail en route to the fishing stream?

Many of the potentially good camping pictures we see have been spoiled because they are too cluttered. They try to cover too many things at once. Probably you have seen the kind of picture I mean: a tent pitched beside a lake, offshore the father casting for trout, beside the tent the mother cooking lunch, children scattered about getting into mischief. Besides being too complicated, it is also puzzling and unreal.

A far better approach to the foregoing camping situation might have been one picture in which the fisherman was framed by the door of the tent. A second picture would have shown, close-up and in detail, what the mother was cooking and on what kind of stove. A third shot could cover the children's activities.

Every good picture has a center of interest—a point to which the viewer's interest keeps returning. It may be the bear standing in a forest glade or a sailboat under billowing sails in a rolling sea. Do not put this center of interest exactly in the center of the picture. Move it slightly and a miraculous change takes place.

Never split a picture exactly in half. Never permit a horizon or similarly strong horizontal line to run right through the middle of the picture. The same is true of a strong vertical line. Move the line to the left or right, up or down, by changing the camera position or camera angle. Even a slight change will make all the difference in the world.

LIGHTING

Ordinarily the outdoor scene photographs best in bright, warm sunlight. But don't overlook scenes with snow or fog, rain or mist. Rainbows show up especially well if you tend to underexpose. Occasionally you can get exciting pictures during unsettled weather, when part of a scene is bathed in golden light and another lies in the shadow of ominous clouds. Watch for chances to shoot scenes with long shadows on the ground.

Backlighting, combined with good exposure in the shaded areas of the subject, are the essence of a good photograph. Wider aperture could have been used here to lighten subject's face.

At late twilight, or even at night, experiment with time exposures. Your camera must be held *firmly,* far more so than you can possibly hold it by hand. You need a tripod, clampod, table, or some solid surface. Every time exposure you shoot is pure trial and error, but luckily you can hardly go wrong. Only extreme overexposure will completely ruin a picture and some underexposures result in the most dramatic effects. Let's say you have a campfire scene, or a storm is approaching and the night sky is laced with lightning. Just set up your camera in a solid place, focus (on infinity to catch the lightning), set the lens at a fairly wide opening and then press the B setting on the lens for one second before releasing it. Next, wind the film ahead and repeat, except to hold the B setting for five seconds. Wind again and hold for ten seconds. One of these exposures should be exactly right. Of course, live subjects will have to remain motionless during the exposure.

For a really unusual twilight picture with an unusual sky, particularly of people sitting beside a campfire, try this: Shoot a time exposure, and during the exposure, use a flash or speedlight to front-light the subjects in the foreground.

A most important point to remember is that dawn and dusk, while a glow of color is in the sky, are better times to take time exposures than is complete darkness.

You can easily photograph any scene with a low sun if you can look at it without squinting. But try it even if you squint. Just compose the picture and then shoot it at the same exposure you would use for that particular film in normal behind-the-shoulder sunlight. Next take two more pictures of the same scene, one with the lens opened two additional stops and a third with the lens closed two more stops. One of those is going to be a striking color photo.

If the sun is below the horizon, figure what the normal exposure would be in bright sunlight and then try three to four lens openings more than normal. If it is an unusually spectacular sunset, try still other exposures and figure that any film wasted is for a good cause.

It may seem hard to believe, but the best moonlight pictures are made in broad sunlight. It's difficult, in fact, to shoot moonlight pictures in moonlight. For one thing, it's hard to judge the correct exposure; but during *any* time exposure (which is a necessity) the moon will move enough to be a blur in the finished photo.

In bright sun, early or late in the day, it's easy. You just shoot into the sun, or with it. In black/white, compose your scene and clamp on a red filter (plus a yellow *and* orange filter, if you happen to have them), increase the exposure accordingly, and shoot. If you *do* use more than one filter, add the filter factors of each together and then compute your exposure as explained in Chapter 3.

Using color, there are two alternatives for moonlight pictures. The first is to use indoor-type film and then to underexpose two or three stops. The bluish picture which will result suggests a bright night under a full moon.

Photographer used simultaneous flashes to silhouette tepee camp during Canadian Rockies pack trip.

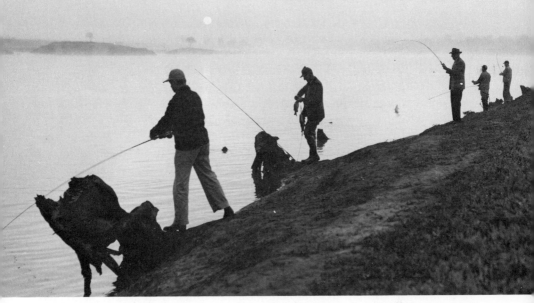

Don't leave your camera in the knapsack because it seems too dark to get pictures. Moments just after dawn, or before sundown, offer fine possibilities, and shooting into sun through early haze gives you simulated moonlight shots.

The other alternative is to use daylight film with a blue filter and under-expose one or two stops. Foreground and shaded subjects appear as silhouettes and the entire scene simulates night. Include an open sun in the picture, if you like, to be the moon, but the effect is more authentic if you wait until it is partially obscured by clouds or overcast.

For the really adventuresome photographer, here's a challenging suggestion. Shoot the actual picture in sunlight as just described, but leave the sun out of the picture. Now, by double exposing (by not winding the film forward), shoot an actual picture of the moon on top of the first picture. By using a telephoto lens on the second shot, you can increase the size of the moon for greater impact.

CONTRAST

With black/white film, today's cameraman has a wide range of tones and shades between complete black and pure white at his command. A color photographer has all the rich colors his eye can identify. The outdoor photographer should make the most of these blessings. One especially effective way is through contrast.

Contrast is nothing more than the difference in brightness. The greatest contrast is achieved by placing a pure black or a very dark color next to a pure white or very light color. The least contrast comes from placing two nearly equal tones of gray or similar pale colors side by side. The greatest impact usually comes from great contrast—a climber in dark clothes scaling the silvery face of a glacier or a deer standing in a pool of sunlight inside a

dark evergreen forest. Keep actively looking for the high contrast scene in your view-finder and you will be rewarded with outstanding pictures.

ACHIEVING DEPTH

Picture frames set off the picture from the wall surrounding the picture. A natural frame within the photograph itself can have a similar effect by helping to center interest on the main subject.

Trees and overhanging branches, particularly if they are in shade and therefore dark, are splendid frames for scenic shots and add depth to the picture. But the frame could also be a cabin door, cooking pots hanging over a campfire, the rail around a corral, snowshoes or a rifle leaning against a tree, a weird rock formation, a set of mounted deer antlers. I have seen good western scenes framed beneath a horse standing in foreground shadows.

A good picture could consist, conceivably, of a significant frame and little more. Examples: a trout fisherman with the sun at his back walking into the arch of a covered bridge; or a boating scene in which the main interest is the dark arch of Spanish moss which completely canopies a southern swamp river. Many landscapes are complete wash-outs unless there is a frame to give them depth and character.

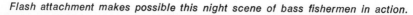

Flash attachment makes possible this night scene of bass fishermen in action.

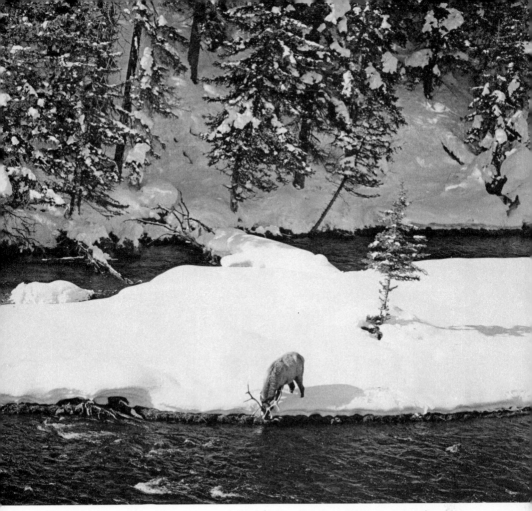

Striking effects can be achieved with black/white film by utilizing contrasting tones and shades as in this natural scene.

Besides framing, there are other ways to emphasize depth in photos. One very effective way is to arrange familiar, recognizable objects or subjects at different distances from the camera. Assume you want to photograph a harbor full of moored boats exactly as it is. By showing nets strung up to dry or lobster pots or busy people in the foreground, you begin to add depth and character to the scene. A river winding erratically into the distance will create depth. So will footprints in the snow leading away from the camera, or a parade of pack horses traveling in single file across a summit.

TRY IT ANYWAY

Some of the most exciting and dramatic outdoor pictures ever made may have seemed too difficult—or even impossible—to attempt in the first place. But if the scene or the situation has great interest, it is also worth trying a picture, no matter how poor the light or elusive the subject.

Of course the result may be nothing at all. But all you have wasted is a

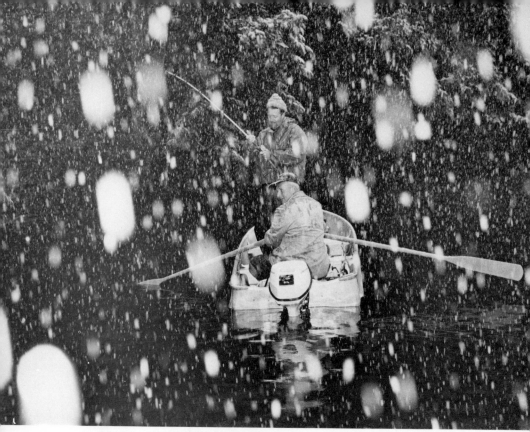

Slow shutter speed magnifies snow flakes in this Wisconsin fishing scene.

small amount of film. The next time you may get a picture which will make you forget all past failures.

It should be added also that the material in this chapter is not meant to be an absolute guide. There are times when pictures completely *without* contrast have far more impact than pictures *with* contrast. One example might be the manner which a snow squall blurs a landscape or a campsite with streaks of white. In the simplest language, shoot anything that looks good to you—or anything you would like to remember.

5 Photographing Outdoor Trips

THE TIME spent making a photographic record of an outdoor trip can be as enjoyable as the part devoted to hunting, fishing, or pitching camp. To compile such a record is neither difficult nor time-consuming; it is simply a matter of covering all the interesting aspects of the trip to produce a well-rounded story. If you approach the problem of recording an outdoor trip made for recreation in the same manner as the professional approaches his outdoor magazine assignments, you will end up with a set of exciting pictures that you will treasure in years to come. Here's how to do it:

THE LOCALE

It is very important to show the locale of any trip. If it is a fishing trip on a lake, there should be typical scenes of the lake. The scenes should show the lake's character—weed beds if it is weedy, timbered shorelines if they exist, islands if they are present. Whenever possible, show fellow anglers fishing from their boats.

If the fishing is on a river, or if the trip includes waterfalls and other spectacular features, they should be included in the record. For example, pose your fellow anglers casting near a waterfall, or show them guiding their boat through a rapids. If it is a surf-fishing trip, show your companions chest deep in the foaming brine.

Hunters should also capture the setting of the hunt on film. A trip into the Rockies should include pictures of steep and beautiful mountains. A small-game hunt anywhere should show the surrounding farm country, the prairies, or the marshes. Duck hunts should include scenes of the marsh at dawn, and deer hunts should cover the attractive scenes which exist in any woodland.

The same is true of boating and camping trips. A boatman can shoot the typical scenes he passes along the way with little more effort than touching the shutter. That would include everything from narrow channels, covered

bridges, and tidal runs, to waterfront villages and government navigation facilities.

Find the vantage point from which the scene is most striking. A mountain range may be more exciting if you shoot from closer range. Or a picture of a lake may be much better if you climb the hillside nearby and shoot from high elevation instead of water level. Try to use imagination and a fresh viewpoint. Don't be satisfied with always doing it the easy way.

THE SEASON

In many cases, the season in which the trip was made can be incorporated into the picture story. The most obvious examples of this would be a carpet of snow on the ground or the scarlet leaves of maple trees in an autumn setting.

Time can be established by showing the clothes which are worn on the trip. Caps with fur ear muffs indicate winter. A fisherman wearing shorts or swimming trunks suggests summer. Trees in bright bloom usually spell springtime. Spring is also accented if your photos show flowers which only bloom during that season. Bare trees mean winter; trees with foliage point to summer or spring. A crust of ice around a pond or in a water bucket can also pinpoint the time.

YOUR COMPANIONS

Although it is possible to enjoy an outdoor adventure entirely alone, most trips are made with at least one other person. No matter what the number, you should include everyone in your photos—companions, guides, boatmen, outfitters, the native people you meet, game wardens.

The best way to capture these people for your photo record is to photograph them doing the things they ordinarily do. For example, shoot several pictures of the camp cook toiling in a steamy kitchen or sticking a thumb in a pot of soup. No matter whether he was a good cook or a bad one, the pictures will be worth plenty of conversation when you show them later.

Guides are always colorful and interesting individuals, and I make it a point to photograph them in a number of different ways. If the guide has a particularly strong face, I shoot a number of portraits, but try to do so candidly rather than by posing. However, there's nothing wrong with posing a person. You can pick an appropriate background—a beard of Spanish moss or the walls of a northern log cabin—and also establish the location. Ordinarily, it's better to show guides engaged in their work. On a deer hunt, you might photograph the guide bending low to examine the fresh tracks he has found in the snow. Elsewhere he might be skinning out a trophy, checking a compass, chopping wood, shoeing a horse, or any of a thousand and one activities.

THE ACTION

No two outdoor adventures are alike. Each has a character and excitement of its own. The setting, the season, and the people are extremely important,

Showing your hunting companions in action will bring more memorable pictures than posing in camp. These two are trying to call geese into range in Texas.

but perhaps the most important part of recording any outdoor adventure is to show exactly what happened.

If it's a fishing trip, show how the fishing was done and how the fish were caught. On a hunting trip, show the hunters actually in pursuit of game. On a camping trip, show the campers pitching tents, cooking, or chopping wood. On a boating trip, show your companions rigging sails or tinkering with the outboard—anything that reveals action.

Action is the most important element in an outdoor photo record. It is hard to put a fishing rod aside long enough to take a picture when the fish are on a striking spree. It is just as hard to trade gun for camera when waterfowl are moving and buzzing into your decoys. But to get a really good, out-of-the-ordinary photo coverage of your trip, you will have to do this occasionally to capture the best action.

When fishing, I always carry at least one camera at the ready. I keep it on the boat seat beside me, covered to protect it from hot sun and spray, with the lens and shutter already set to take an action picture. This presetting is extremely important because once a fish is hooked, it is usually too late to make the setting and to get good photos.

Once my fishing partner has a strike, I put down my own rod and pick up the camera. Instantly I'm ready to shoot anything—the fish jumping, the strained look on the fisherman's face, the dancing rod, or the fisherman gaffing the fish and swinging it on board. That done, I can return to my own

fishing again. And if *I* have a strike, my companion or the guide (whom I often instruct in the use of my camera beforehand) can start shooting pictures of me fishing.

While hunting, an alert cameraman can make some unusually good action shots. These do not necessarily involve the game. They might show another hunter making a stalk—creeping and crawling on all fours up a steep hillside, climbing over a deadfall, or wading a creek. If artificial calls are used to attract the game, pictures of the caller give good action. The antics of hunting dogs also make exciting action photos.

Sometimes the most interesting action does not involve the hunting or fishing, and a photographer should always be alert for these. Several years ago we bagged a huge black bear deep in a remote Utah canyon and after

Pictures of fish held before the camera don't have to be dull or routine—try to catch that expression of genuine surprise, satisfaction and pride in the angler's face.

skinning it were faced with the problem of carrying it out of the canyon. Somebody suggested lashing the hide to the saddle of a horse we'd coaxed into the canyon. But the horse didn't exactly go along with the idea. Sensing the horse was nervous, I had my camera ready when she broke away and went bucking all over the canyon with the bear hide dragging behind.

Even bad weather can produce great action pictures. I remember a hunt high in Montana's Rockies when a storm broke and swirled above us for two days without let-up. At first we sat in camp, suffering from the boredom. Then out of desperation more than anything else, I made pictures of my companions and the wranglers removing the snow which was collecting on the tents and of wranglers riding out in a blinding snow squall to look for lost horses. They're off-beat pictures, of course, but they certainly tell the story of our trip.

As in any other specialized kind of photography, experience in the outdoors is very important. An experienced fisherman can anticipate the strike of a fish or the moment when it jumps—and he can be ready for it with a camera. By carefully watching the way his dog works in the field, an experienced hunter can anticipate when a bird or rabbit will flush from cover.

But even relatively inexperienced outdoorsmen can take excellent action pictures. One way is to enlist the help of the guide. Usually he can tell you when something is about to happen. When filming fishing action, I often ask the guide to keep me informed of what is going on outside of the viewfinder through which I'm watching the action. He can also help me stay in focus by reporting—"The tarpon is 30 feet away . . . now 25 . . . now about 20 feet." When he says "coming up," I can look for a jump in the next few seconds.

It must be obvious that even the most alert and prepared cameraman will not catch all of the important action on any trip. But he can fill the gaps by making setup shots. It is slightly time-consuming and will require help from companions, but my own outdoor companions have always been more than willing to participate in such projects.

To illustrate the setup picture, I'll go back to a fishing trip in Wisconsin when my friends Bill Hendershot and Dick Schneer hooked a good muskellunge while casting from another boat. My camera was handy, but I'd neglected to change film. Before I could complete the job, the musky was netted and in the boat. I asked my friends to land the fish again. They imbedded the hook firmly in the musky's jaw and Dick proceeded to swing the fish briskly aboard several times while I snapped away. Sometimes the setup shot may result in a better photo. In this case, by slightly adjusting the location of the boat, I was able to obtain a better background—a blue sky that didn't conflict with the action, which was the main point of interest.

Often while hunting or climbing in the mountains I've passed up spectacular pictures because the light was too poor for good results. But if the picture was exciting enough, I would arrange to return in good light for a setup picture. A good percentage of magazine cover pictures are actual incidents recreated with more favorable light and background.

ENLIVENING YOUR PICTURES

There are a number of ways to brighten up the pictures of any outdoor venture. If you want to take outstanding pictures instead of just adequate ones, keep the following tips in mind, particularly when you're shooting in color.

Carry props whenever possible. In most cases, hunters wearing brightly colored shirts or caps make far more attractive subjects than if they wear khaki or olive-colored clothing. Of course, there are exceptions to this—as when camouflaged or drab equipment is an essential part of the trip.

Much of my outdoor gear has been purchased with photography as much as utility in mind. My tents, sleeping bags, and even my canoe, are brightly colored because I feel they will be more striking when contrasted with the greens and blues of the outdoors.

Especially in camping, extra props (spare lanterns, novel cooking devices, etc.) are very important in posing an attractive scene. Since much of the joy and fascination of camping lies in living close to nature, it is always well to take pictures of the ingenious devices and gimmicks which make camping comfortable. If you build a portable shower, photograph somebody standing in the spray. If you've devised a novel method of rigging a tent, show it in a picture or two. If your family prefers some unusual type of camp cooking, be certain it's on film before you break camp.

Alert photographer caught this pine squirrel raiding the strawberry jam. With telephoto lens he was able to block out background and illuminate center of interest.

Sometimes it helps to use purely local items as props. This could include everything from wearing Eskimo mukluks to floppy straw hats typical of the Bahamas. Such a simple prop as a machete worn by a guide or the silver spurs typical of Montana ranches establish both the setting and the mood for your pictures. Maps or charts of the local area are always suitable props.

BOATING TRIPS

Photographing a boating trip involves a few unique problems, mostly because of the water and the motion.

To avoid losing your camera overboard use a small, light camera with a neck strap. If possible, use two cameras. Then you'll always have one ready to catch spur-of-the-moment shots that allow no time for reloading.

A good exposure meter, filters, and a sunshade can help you get better boating photographs. Water reflects much more light than land, so you're liable to overexpose unless you check your exposure with a meter. With black/white film, a yellow (K-2) filter will darken blue sky and bring out clouds. For dramatic, moody effects use a red filter. The filters protect your lens from spray. A sunshade also helps keep spray out of the lens.

To get good results when shooting from a moving boat, use the fastest shutter speed possible. Never shoot a fast-moving boat at less than 1/250 of a second; 1/500 is much better.

When possible, get above the boat to shoot the action, as in this rare photo of an archer jockeying for a shot at a large leopard ray hooked by fisherman in the bow. This was taken from Seven Mile Bridge in Florida Keys.

If your shutter speed is limited, you can stop fast action by using a couple of tricks to reduce a boat's relative speed. The speed of the subject boat is highest if it passes you at right angles and you are standing still. Here are three ways to reduce the speed of the other boat: shoot at a reduced angle as the boat approaches you; pan with the moving boat and shoot as it passes close to you; shoot from a boat moving at nearly the same speed as the subject boat. This gives excellent results because it stops the boat and the distant background, too, and gives you motion in the water.

When shooting from a running power boat, don't rest the camera against any part of the boat. Vibration from the engine will blur your photos. Your best bet is to hold the camera against your cheek. This helps steady the camera and also keeps your eye centered in the view-finder.

When reloading aboard a boat, go into a cabin or under the canopy, if possible. Otherwise, shade the film from the direct sun with your body.

CARE OF EQUIPMENT

Some extraordinary outdoor pictures have been lost by carelessness. Both cameras and film have been damaged or even completely ruined by exposure to rain and heat. Every outdoor photographer must protect his equipment.

Keep your camera in a waterproof bag. Never allow the camera to remain in the hot sun for very long.

Always check the neck straps for undue wear.

Keep the lens clean. Optical glass is softer than other kinds of glass and the coating used on a lens is extremely thin. Protect the lens with a cap or lens cover, but remember to remove it when taking pictures. Many excellent pictures have been lost by such forgetfulness. An alternate method is to cover the lens with a filter of some sort, perhaps an ultra-violet filter.

Lenses also need periodic cleaning. Dry dust should be removed with a soft camel's-hair brush or by blowing it off with a small ear syringe. *Never blow or breathe on a lens element.* Your breath contains moisture which will leave a film on the glass and affect the lens' ability to transmit light.

Never touch lens surfaces with the fingers. Fingerprints contain acid perspiration which can actually etch the glass and damage it permanently. If you do accidentally touch the surface with your fingers, polish the glass gently with a special lens-cleaning tissue. Do not use the tissue dry; instead, add a drop or two of good commercial lens cleaner and apply with a circular motion.

Warning: Do not use a handkerchief or other cloth to wipe a lens; the lens can be scratched by dust or grit embedded in the fabric. Facial tissues aren't very good either because they leave residues of dust and lint on the lens.

Never tinker with the mechanical elements of a lens. This is a job for specialists.

Do not attempt to grease or lubricate moving parts of your camera. Lubricants thicken in cold weather, and that can mean the camera will not operate on a hunting trip. In normal use, a camera lens requires no attention other

than an occasional cleaning to keep it performing perfectly, day after day and picture after picture.

IDEA CHECKLIST FOR FISHING TRIP

- Scenes or landscapes of the fishing country. Show typical features of the region.
- Scenes showing type of water fished. Add fishermen to these pictures.
- Close-up of flies or lures used, especially if the baits are at all unusual.
- Action: playing fish, casting, netting fish, fish jumping. Remember to use fast shutter speeds on all these. When actually out fishing, always have camera preset and ready to use. But keep the camera in the shade.
- Casual pictures: friends having bull session or enjoying cocktails in camp or around the campfire.
- The cook and/or cooking facilities. Show cook in action in the kitchen or a close-up of a platter-full of fish.
- Trophy pictures showing members of party holding fish. Concentrate on filming largest fish rather than large strings. Try to keep fish fresh for filming. Nothing looks worse than display of old dried out or faded fish. A good way to avoid this is to shoot the trophy photos as soon as possible after the catch.
- Pictures of the guide—portraits and doing camp chores.
- Tying flies or checking tackle. Repairing waders or sewing a rip in pants.

Keep your camera ready and available for shots such as this struggle between fisherman and pike.

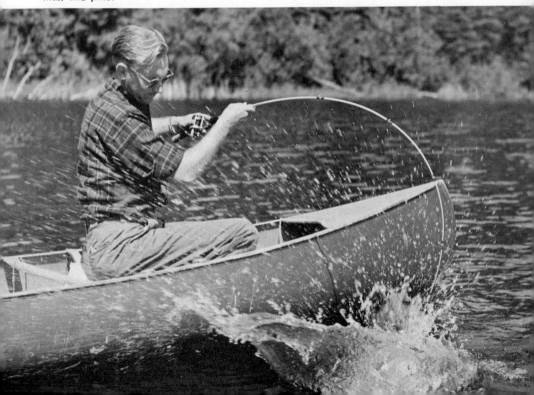

- Portrait of fishing companion with cap full of flies. Or sound asleep on the shore.
- Still life of fish in native setting—with moss or flowers or colorful rocks. Remember to use *fresh,* unmarked fish.
- Mood pictures—of covered bridges, hovering sea birds, old cabins, light-houses, sunken boats near the fishing water.
- Equipment used—rubber rafts, outriggers, kites, unusual tackle, spears, shanties (if ice fishing), etc.
- Camp, especially if a colorful tent or wilderness camp. Interiors and exteriors. Have boots and socks drying out on a clothesline.
- The boat used with fishermen in it, especially if boat is unusual or has a special distinguishing character, such as a native dugout or sampan.
- Extreme close-up of fish caught—to show teeth or special marking, or with fly or lure used in its jaw.
- Entire fishing party gathered by some distinguishing landmark or prop.
- Guide or someone filleting or dressing fish. If unusual method or tool is used to dress fish, show it.
- Gathering bait, especially if some unique trap net, cast net or other device is used.

IDEA CHECKLIST FOR HUNTING TRIP

- Scenes of the hunting country. Show typical features of the region.
- Hunters in act of hunting: climbing, driving a cornfield, slogging through a swamp, crawling up slope, on stand, kicking brushpile, etc.
- Still life of all the firearms in the group. Make this a close-up.
- Using binoculars or spotting scope of a big-game hunt.
- Dogs straining at leash, criss-crossing field to find birds, on trail, pointing, retrieving and swimming. Also try to get portraits of dogs. If hounds used on big game, try to show scars and perforated ears, etc.
- Hunters relaxing in camp, over cocktails or bull session. Show socks, boots, red flannel underwear, other gear hanging up to dry.
- Trophy shots of hunters with game. Try to avoid pictures of game heaped up. Concentrate on a few very good trophies. Remember that any game is better photographed as soon as possible and before it has stiffened. In some cases, the best trophy shots are of hunters stretching out and measuring hides.
- Skinning out or dressing game. Show how meat is cared for and preserved.
- Mood pictures: hunters returning at sunset, rainbow after the storm, ice on the water bucket, fallen leaves, tracks in a fresh snow, munching on apples or persimmons in the woods, drawing water at an old well.
- Pack mules at work and panoramic views of the pack train. Keep alert for balky animals to throw their loads for good action.
- Blinds and decoys. Show details of both. Show hunter tossing out decoys.
- Calling game. Close-ups of both the calls used and the caller.
- Common animals and birds which visit camp—jays, chipmunks, squirrels.
- Guides, trackers, drivers, and dog handlers doing their jobs.

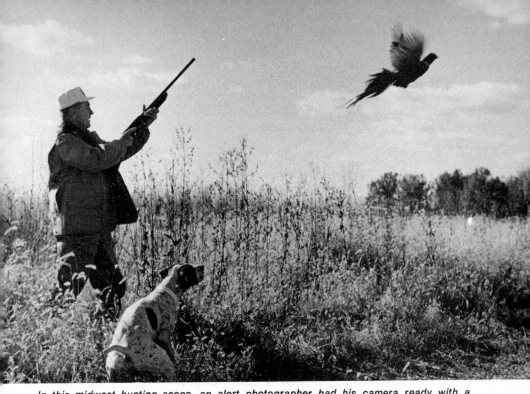

In this midwest hunting scene, an alert photographer had his camera ready with a fast shutter speed at the correct exposure and captured this action photo.

Both of these men are genuinely apprehensive. That Cape buffalo is potential murder if it is not dead, and another one is lurking behind them.

- Vehicles used on the trip—jeeps, ox-cart, boat, donkey, pickup or Shanks' mare.
- Traditional camp rituals such as cutting off hunter's shirttail or presenting fur-lined pot.
- Any unusual equipment or gadgets used. Example: ski-sled to transport game back into camp.
- The camp scene, plus any natives or other visitors (such as the game warden or ranger) in camp.
- Planning strategy—checking maps, compasses, and wrist watches.

IDEA CHECKLIST FOR CAMPING TRIP

- Scenes of places visited on the trip.
- Campsites visited, showing camp in best relation to the environment. This should show distinguishing marks of the region.
- Action shots of pitching the tent and setting up the camp.
- Cooking—no matter whether open fire or on modern propane stove.
- Shaving al fresco, perhaps beside a stream with mirror on a tree trunk.
- Any unusual camping devices or gimmicks used. Example: boat overturned and used as a table.
- People crawling out of sleeping bags in the morning.
- Camp visitors, both people and animals (chipmunks, squirrels, birds, bears, etc.).
- Views along highways traveled, showing camping trailer or unit in the scenes.
- Family flag or identification marker hanging beside camp.
- Bathing or swimming in lake or creek near camp.
- Fishing, rock-hounding, bird-watching, hiking, climbing, canoeing, repairing equipment, or any other activities common to campers.
- Huddling in tent during bad weather or rain squall. Maybe fallen tent after sudden storm.
- Clothes or wash hanging out on a line to dry.
- Panoramic view of the entire campground showing as many camps as possible.
- Activity around the campfire after dark—singing, story-telling, brewing coffee, patching clothes, etc. Great chance to show the true mood and joy of camping.
- Display of all the gear and camping equipment used on the entire trip by the party. Try to shoot this from overhead to better show everything.
- If children are on the trip, try to get as many unposed shots as possible of the youngsters having the time of their lives.
- Whole family poring over maps, charts, pamphlets to decide where to go next.

IDEA CHECKLIST FOR BOATING TRIP

- Scenes of places, lakes and rivers visited, both *from* the boat and *with* boat in the pictures.

- The crew, a group picture and pictures of them doing normal chores.
- Places passed or visited en route: picturesque villages, harbors, lighthouses, fishing wharves, rapids, navigation locks, other boats, marinas, waterway restaurants.
- Cooking on board. Photos of cook. Emphasize the inconvenience of a small galley. Emphasize any unique cooking devices.
- Relaxing aboard—sun-bathing, playing cards, reading.

A high angle emphasizes the beauty and adventure of river float trip in Southwest Ohio.

- Fishing, what fish caught? What tackle and bait used? Trophy pictures.
- Hoisting or lowering sail; crew member climbing in rigging.
- Making repairs or tinkering with engine. Shot of mechanic with grease on face.
- Diving from deck, swimming, skin-diving. Show details of scuba equipment.
- Sunrises and sunsets over water are especially photogenic. Shoot them.
- Negotiating rough or difficult water. Try to show uneven attitude of the boat, the waves, crew members straining at various tasks.
- If canoe trip, show a display of all gear taken along. Show portaging gear.
- Raising flags—yacht club streamers, cocktail, and "fish caught" banners.
- If cruise with other boats, photos of entire fleet underway or docked somewhere together.
- Camp, picnic, barbecue, or fish fry on shore.
- Digging clams, hunting oysters, or beachcombing. Show things found—from geoducks to driftwood.
- Photos of sea birds encountered—gulls, terns, pelicans—and porpoises or other waterway wildlife.
- Sleeping or living on board. Rolling up sleeping bags, swabbing decks, waterskiing, applying suntan lotion, etc.
- Pictures of pets on board.
- As many candid shots as possible of children. Show safety devices used with youngsters.
- Boating photos are great opportunity to photograph gay, colorful clothing. Take advantage of it.

IDEA CHECKLIST FOR PACK TRIPS

- The beginning of the trip, the actual loading of pack animals. Often this is a time when the horses may be reluctant to be loaded and try to throw their cargoes. That means there may be sudden exciting action to film.
- The intricate knots used on pack saddles. Tying pack horses head-to-tail before hitting the trail.
- Scenes of the pack string winding through a forest, fording a stream, passing in profile over a ridge or high pass.
- Trail signs and mileage markers along the way.
- Rounding up the horses in the morning. Saddling horses.
- Horses rolling on the ground after their pack saddles and cargo have been removed.
- Pitching the camp. Ask the outfitter to place tents so that they will be in the most scenic position and with the most scenic background.
- Evening campfire and cooking.
- Ride out ahead of the group and try to get oncoming (as well as going away) pictures of the pack string.
- Fishing, hunting, exploring, or whatever the original reason for the trip.

A good photograph tells a whole story. Here, the camera caught the action, tension and excitement of a backpacking trip.

IDEA CHECKLIST FOR BACKPACKING

- Details of all the backpacking equipment taken on the trip. Show all of it in a neat arrangement.
- Trail scenes in attractive places, through deep canyons, at scenic overlooks.
- Catch hikers, prone, sipping water from clear cool stream.
- Cooling bare, tired feet in stream.
- Details of any overnight camps. Locate tents as much for the beauty of the situation as for convenience.
- Hikers stretched out on ground, packs off, at end of day. Possibility exists here for humorous, off-guard pix of completely exhausted companions.
- Wildlife and wildflowers encountered along the way. In many areas, hikers will see more wildlife (because of the quiet approach) than anyone else. They will also have unusual opportunities to "shoot" it.

- Unusual or pioneer camping and cooking techniques. Making do with little gear.
- Trail signs and markers, trailside shelters, lean-tos or other facilities especially for backpackers.
- Fishing, exploring caves, climbing, rock hunting.
- Collecting wild edibles or using any survival techniques for the experience.
- Hikers helping one another over difficult places.
- Crossing a stream on stepping stones or a log bridge.

IDEA CHECKLIST FOR CROSS-COUNTRY SKIING OR SNOWSHOEING

- The basic equipment, skis or snowshoes. Show how skis differ from those of downhill skiers. In a party of snowshoers, there may be several different types of webs. Show all together for the contrast.
- Traveling through exquisite winter scenes. Try to emphasize mood with heavy snows hanging from trail shelters or from evergreen trees.
- Lunch break on the trail.
- Wildlife encountered. Keep in mind that many birds and animals allow a close approach in winter.
- Back-lit pictures against low sun to emphasize snow glitter, or white breath of skiers against a dark background.
- Downhill runs, perhaps with a spill in soft snow at the bottom.
- Patterns left behind by skis or snowshoes across fresh snow. Watch for herringbone marks in wake of skier traveling uphill.
- Beginners learning proper techniques.
- Backpacking or camping via skis or snowshoes.
- Close-ups of colorful face masks sometimes worn.
- Spectacular winter scenes, in some of which the skiers dominate, others in which the scene is most important. Watch for shadows, patterns of deep snow drifts.

IDEA CHECKLIST FOR USERS OF RECREATIONAL VEHICLES

- Few rec vehicles, no matter whether a trailer, tent trailer, motor home or pickup camper, are really attractive. To best film any unit, photograph it in scenic places, perhaps where it is partially hidden, shaded, or where it best blends into its background.
- Traveling shots on scenic highways. Head-ons or ¾ views of the vehicle usually are best.
- Overhead shots from highway crossovers or of crossing bridges from below.
- Interiors. Someone cooking or relaxing, tinkering with fishing tackle.
- Vehicle maintenance. Filling water tanks. Leveling. Washing away road grime.
- Fishing, with vehicle not too prominent in background.

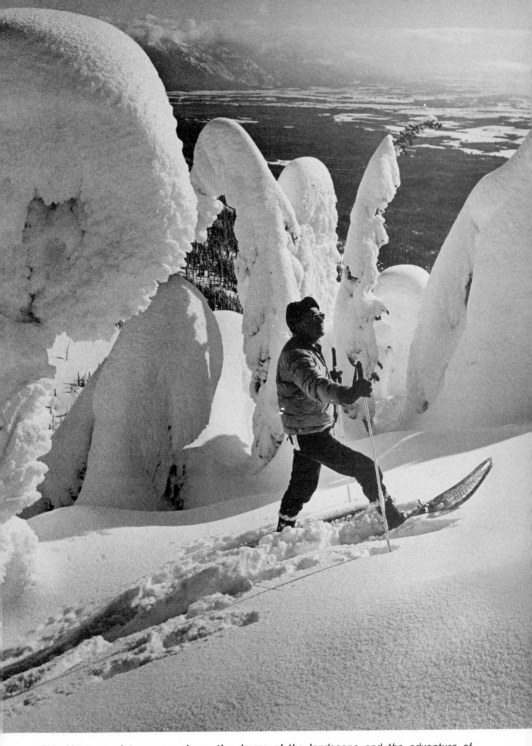

This Montana winter scene shows the drama of the landscape and the adventure of a snowshoeing expedition.

- Frame vehicle in canopy of trees, underneath bright clothing drying on a line, or beneath stringer of fish held up by two anglers.
- Loading or unloading canoe or cartop boat. Or motor bike from brackets.
- Clusters of window or bumper stickers collected during travels.
- Highway scenes shot from interior of the cab.
- Scenes of unusual natural beauty framed through a picture window of the vehicle.
- Camper vehicle caravans on the road.
- Scenes of campgrounds from a distance, showing your vehicle among others.
- Typical campsite activities. Gossiping. Cocktail hour. Cooking or barbecuing outdoors. Sunbathing. Neighbors. Evening bonfires. Naturalist lectures.

6 How to Shoot Snowmobile Pictures

RECENTLY A busy photofinishing company reported that their customers shoot the poorest pictures during winter—particularly on snowmobiling and skiing holidays. That isn't any wonder because the average cameraman is never faced with such extreme conditions. For example, the light can vary from the dazzling brilliance of sunshine on new snow to almost total gray on dark days. There is also intense cold to consider, although that is the least of a photographer's concern as we will see.

But problems notwithstanding, taking good pictures of any type of snowmobiling activity is not really difficult. In fact some of the most spectacular outdoor pictures of the year are possible when snow covers the ground. Let's see how to make them, starting first with the equipment.

CAMERAS

Used properly, almost any of the cameras already described are suitable, except possibly those which are completely automatic (set the exposure, no focusing, etc.), and even these can be used for certain posed pictures. However the ideal camera is the 35mm with a shutter speed of at least 1/500 second (and 1/1000 is better), plus a telephoto lens of about 135mm to be interchanged with the normal 50mm lens.

As in other outdoor use already described, the 35mm is best because it is the smallest, lightest, most compact and most able to withstand rough handling. All of the 35mm cameras will also handle rolls of up to 36 exposures, which is a great advantage because changing film with cold hands is not so often required. Very low temperatures can make film very brittle and the less handling of it the better. Be especially careful when loading and threading it into the camera. Advance the film slowly.

A telephoto lens is not absolutely necessary, but it can bring distant action

much closer and may prove to be the best one all the time when photographing a snowmobile event, say from a bleachers. Any lens should have a lens shade in snow situations.

When shooting over snow, nothing causes a cameraman more trouble than the correct exposure. Improper setting of lens openings and shutter speeds is the main cause of failure—of taking "non-pictures"—and is the first thing a snow cameraman must master.

EXPOSURES FOR WINTER

During summertime, a photographer can cope very nicely just by consulting the data sheet which comes inside every box of film. On this sheet there is a table of exposures to use for such varied light conditions as bright or hazy sun, cloudy bright, open shade, heavy overcast, etc. This works very well, especially if the cameraman brackets one-half f-stop on each side of the suggested exposure to compensate for error. But with snow on the ground, the table doesn't work quite so well and without much experience, neither does the photographer's judgment. The only positive way to assure correct camera settings is with a reliable, sensitive exposure meter. *But the meter must be used properly.* That point cannot be overemphasized.

Assume you are photographing a friend astride his brand-new colorful machine. He wants this one, grin and all, for the family album. It's a clear sunny day to boot. To properly expose for the picture, you move in close and read the exposure meter when aimed at his face or perhaps at his snowmobile suit, then set the camera accordingly. Do not just aim the meter from

A sharp telephoto lens eliminated background detail in this photo, and focused on lady snowmobiler.

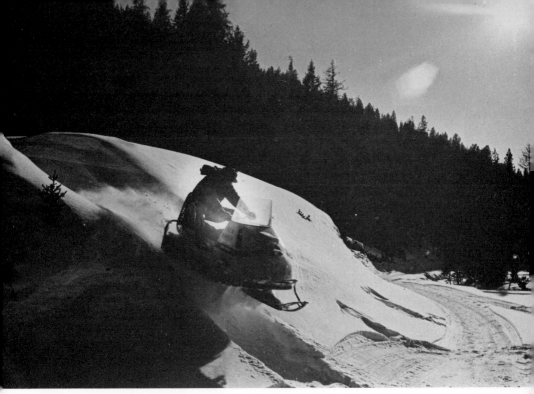

Back and side light produces dramatic contrast on shadows and tracks in the snow. A lens hood is helpful here to minimize glare from direct light.

a distance in the general direction of the scene—or toward sky or snow—because the reading will then be inaccurate and the picture is certain to be underexposed. The best meter to use is the spot sensor type, although these are expensive.

Keep this firmly in mind: expose for the central or main subject, no matter what it is, and forget about the rest.

As anyone knows, snowmobiling is an exciting, motion sport. To really capture the excitement and motion on film, it's necessary to stop the action—in other words, to use a fast, usually your fastest, shutter speed. Next to improper exposure, blurred or indistinguishable pictures are the winter sports photographer's greatest errors.

Especially on very bright days, a good way which even pros use to eliminate mistakes is to set the camera on its fastest shutter speed, and to leave it there. The only adjustment then necessary is in f-stops to match changing light conditions.

However, exceptions tend to prove all rules and this is no exception. There may be a few times when blurred photos will actually do the best job of illustrating speed or action. Say you are photographing a race on a fixed track. Get a place close to passing machines, set the shutter speed at 1/60 or 1/100 second or so and shoot as the racers whiz by. Some viewers will consider the liquid blur or streak of color you obtain on film as being highly creative or artistic.

FURTHER HINTS FOR WINTER PHOTOGRAPHY

Photographing any snowmobile event can be a fascinating part of the game, no matter whether the aim is color or black/white prints for a club album, slides for projection or motion pictures. Virtually all of the following suggestions apply to any of these.

- Carry the camera and lenses in a waterproof container such as a plastic bag. The leather carrying case which comes with the camera is not the best for this purpose and is only a nuisance when changing film.

- Keep snow brushed off the camera and especially off of the lens. When snow melts the water can trickle down into moving parts, later to condense or freeze. If you wear the camera around your neck, keep the strap short and the camera up close under the chin to keep it from bouncing, and out of the way of driving, etc.

- If it can be avoided, do not bring a cold camera suddenly into a warm place and vice versa. All kinds of condensation and freezing problems can result. It is better to keep the camera in a dry, cold place outside when you have to go indoors. Cold has no detrimental effect on color or black/white film, but changing temperatures can be very harmful.

- Shoot scenic pictures such as snowmobiles touring through a northern woodland or across a snow-covered meadow early and late in the day if possible. Often when the sun is low, a rich golden glow is added to the snow's surface. A low sun also lengthens and deepens shadows for dramatic effects.

- Try to plan ahead as much as possible. Assume for instance that you are photographing a cross-country race. First pick a convenient spot which the racers must pass and then select your own best spot to shoot, taking advantage of the strongest light, the best angle. Pre-focus on the exact place the racers will be, or exactly where *you* want to shoot them, so that you need not bother with focusing when the racers come speeding your way.

- Always look for unusual angles. Example: Catch a snowmobile suddenly emerging over the top of a ridge. Example: Shoot down on a race from a bridge or the luggage rack of your own car. Example: Use a telephoto lens to get head-on shots from a distance just as the racers go into a turn. Expect to find more snow flying and more action on curves than on straightaways.

- It is worthwhile to shoot some pictures directly into the sun. But except when the sun is very low or partially obscured by haze or clouds, try to keep it hidden behind a person, tree or snowmobile. Direct bright sunlight on the lens will ruin the exposure.

- Photograph the small details—things which may seem insignificant at the time—which are a part of any snowmobile event. Some good examples are the colorful club flags, shoulder patches and insignia. Watch also for frosted parka hoods, for gals who look good even upholstered in quilted clothing, marking the official scoreboard, mechanics dissecting and repair-

Plan your shot ahead of time: Pick a spot, set shutter speed, and shoot as soon as subject goes by.

ing their vehicles, the loser's disappointment as well as the winner's smile.

- Use a telephoto lens for portraits or close-ups of people because the narrower depth of focus will eliminate distracting detail from the background.
- The after-the-race or after-the-trail-ride barbecue is a good subject. Shoot the whole gang together, but don't forget the meat cooking on the fire or close-ups of a small youngster trying to surround a large sandwich. A flash unit will be handy if these barbecues happen after dark or on cloudy days. Batteries in flash units tend to lose power on very cold days.
- Today the snowmobile is a means of reaching remote places of great beauty which remain inaccessible any other way, such as frozen waterfalls, rivers locked with ice, huge icicles, entire evergreen forests wearing a fresh burden of snow. Take time to film these scenes with and without the snowmobiles in the foreground.
- Most activities associated with snowmobiling are often worth photographing. Some examples: clearing or marking trails, safety instruction for beginners, ice fishing, laying out the course for a race.
- If snow is falling and you want to show it in your pictures, fix the shutter speed at 1/25 or 1/30 second. At faster speeds you would otherwise use, the flakes will not show up at all.
- A good shot is one of the passengers on a snowmobile, or of other snowmobilers traveling ahead and following on a trail. The fast shutter speed is necessary here. Also, some of the finest running shots of snowmobiling can be made by a photographer traveling in one machine parallel to the subject. This emphasizes the action and excitement. However do not try

These human interest shots make it clear that snowmobiling is fun for young and old.

Snowmobile trips offer opportunity to show dramatic snow effects in your pictures.

to drive and take pictures at the same time; the results are usually poor, and I once saw this cause a bad accident.

- The most important tip toward better snowmobile pictures is to emulate the pros by carrying a camera all the time and shooting plenty of pictures, probably far more than appear to be necessary. Never pass up a chance at something unusual. If you missed an important picture, try to set it up for a second try by asking the subjects to repeat the action. Snowmobilers are friendly people and most will gladly oblige. Besides, who doesn't like to have his picture taken?

7 Animal Photography

ANIMAL PHOTOGRAPHY—in some cases hunting with a camera—must rank as the most challenging and rewarding of all photographic hobbies. There are no closed seasons, no bag limits and no expensive hunting licenses to buy. Your targets may be endangered species as well as the common cottontails in your garden. And make no mistake about it, the striking framed photo of a wild animal is as satisfying as a trophy head mounted on the wall—and is not nearly so dust-catching.

Animal photography can be divided into two categories—shooting pets or domestic creatures and photographing wild species. Pets are the most accessible; your basic aim is to get their attention and to encourage them to perform. Photographing wild animals is a vastly different and a more demanding undertaking because the subjects have far keener senses of sight, scent and hearing than any human. They must be furtive and cunning just to survive in the wild, and thus, instinctively avoid people, even those armed only with a camera. But much of the camera handling experience gained in photographing pets can be applied later on when wild animals are the targets.

PHOTOGRAPHING PETS

Consider pets first—particularly dogs—and let's see what can be done about capturing them on film. For far too many owners of hunting dogs—or any dogs—taking good pictures has proven frustrating. But really good photos of man's best friend are possible for almost anyone with a modern camera, plus a measure of patience and practice.

A hunting dog is a handsome, usually eager to please, and an always available subject. Of course a few dogs, like some people, freeze whenever anyone aims a camera and this is difficult to explain. Usually the dogs are

just shy. But if handled properly most are as happy as politicians to be photographed. One way to avoid the problem is to keep a camera handy, in sight, or even in hand much of the time so that the dog gets used to it.

There are two types of dog pictures: the portrait which shows the animal itself, and the action shot which shows what the dog does or can do. Portraits obviously are the easiest photos and they can be shot in a number of ways. One method (if you have plenty of time to kill) is to try to catch the dog unaware, to completely preset the camera and to follow the dog without making a fuss over it until it reaches some posture which looks suitable. But for every good exposure you make this way you will have a good many others to discard.

However, I prefer to "set up" the picture, especially with dogs which are obedient. First I take the dog into open bright light, on a leash if there is a chance it will break away and range far, and scuffle or play with it to get acquainted. Next I command the dog to sit (if for a head shot only) or to stand (if to shoot the whole animal) and try to make one or two exposures immediately. Normally there is a short interval when the animal is curious about why the play has suddenly stopped and this expression is good to shoot.

Next, with the dog still in place and the camera focused on the subject, I make squeaking noises or blow a whistle or even suggest a reward of food to obtain other expressions on the dog's face. If the dog belongs to someone else, he can be doing all these things while the photographer is free to concentrate on his equipment.

Different dogs have certain peculiarities and are excited by certain actions. Try to discover what these are and be ready to shoot. Approach a dog in its

For dog portrait, make sure lighting is right and preset camera at estimated exposure. Then get pet up on bench or table at camera level, make strange sounds to produce photogenic behavior. Large lens opening blurs out distracting background.

kennel, for example, with a gun and a familiar hunting coat, then watch for the eager, almost evil anticipation in its eyes. Or take out one dog, and have your camera focused on the frantic disappointment of another left behind. Countless other tricks work as well.

A common mistake when making dog portraits is to shoot from too far away—or to shoot down on the dog rather than from the same level. At times it may be a good idea to place the dog on a bench or table. Another mistake is to use a slow shutter speed. I always use the fastest shutter the exposure or the camera permits to compensate for either the dog's movement or my own. I also use a short focal length (say a 2X) telephoto lens.

If the dog is light colored, try to shoot it against a dark background and vice versa. In any case, the background should be plain, without distracting objects and whenever possible out of focus. Accomplish this by using a telephoto lens (rather than the camera's normal focal length lens) and the fast shutter. It is difficult to capture solid black details, such as very dark Labradors. I have found that if the surfaces are wet rather than dry it's a great improvement.

When shooting a picture of a dog and his owner, instruct the man to simply be natural with the animal. Pet it, talk to it, ruffle it—anything like that while you are focusing on the animal.

Good action shots depend more on good planning and on how well the dog can be controlled than on expert photo techniques. To film a setter on staunch point, for example, you need only to put a pigeon or pheasant, dizzied so that it will not fly, exactly where the background suits you best. Then if the dog holds the point as it should, you may move in for all the angles you want.

Shooting a beagle or any other hound running a trail is easy enough. First flush a rabbit and watch carefully for the exact path it runs. Next station yourself right beside the path, focus the camera on it and release the dog. It should follow in full cry on the track made by the rabbit. Again remember to use the fastest shutter possible.

Retrievers are even easier to photograph in action, although you probably will need someone to assist you. Select a spot where you would like the dog to pass you—perhaps the exact spot to hit the water in pursuit of a tossed object. Set up right there, pre-focus on the spot and have the assistant throw the object so that the dog will dart past the place you have selected. It is even possible to make a very dramatic head-on running picture in this manner. Next swing around and catch the dog during the retrieve.

Any coon hunter can shoot excellent pictures of his hounds during an actual chase—barking at a tree or trying to climb it, swimming a creek, jumping a fence—by equipping his camera with a flash unit. The same unit can be used for daytime portrait pictures when a bright sun is directly or nearly overhead. The light will fill in places which would otherwise be dark shadows.

Start shooting pictures of your dog as soon as possible after it is whelped or after bringing it home from the kennel. Several years ago my son received

Author's beagle, Hungry Homer, is as willing as a politician to be photographed. Here he lets off a howl when a certain question is asked.

Here's Homer in action. Following after him with camera set and ready for use, photographer took this shot of flushing pheasant and dog close behind.

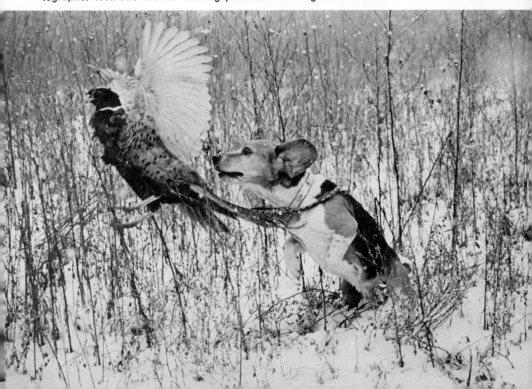

a beagle puppy for Christmas and late the same day I shot pictures of the two of them sound asleep under the Christmas tree. Action photos of cavorting puppies are always delightful and later I made many pictures of the boy training his young beagle with a duck wing tied to a string and stick. I also had a camera along when the lad winced as a vet gave the puppy its first rabies shot.

Watch always for the unusual antics of puppies—as when retrieving a strange object, splashing in water for the first time or hiding behind a hunting boot it was caught chewing. Whenever possible, take advantage of a young dog's extreme curiosity about unfamiliar sounds and movements.

Getting good photographs of dogs actually hunting is seldom easy, and here is where experience with the animals is very helpful. If you have not owned or handled dogs, a good place to gain experience quickly (and where plenty of canine photo subjects will be handy) is at a field trial. These contests, which are held everywhere for all sporting breeds, determine a dog's hunting skill. Here a cameraman can get an idea of how the different breeds work and behave in the field.

For hunting pictures, you almost have to anticipate a dog's behavior. With your camera set, pre-focused as much as possible, try to position yourself in the field near the path of a crossing bird dog. If a rabbit is flushed—or if you spot the rabbit running ahead of a beagle—be in position to snap the hound as it follows the trail. Photographing retrievers in action is easier because one can be in the right place when the dog returns to its handler with a pheasant or duck. Often the handler can assist you by calling the dog or directing the dog past your camera position.

An especially good time to catch a dog in action is immediately after it has been released for the hunt. Be ready to catch it exploding out of a kennel, over the tailgate of a station wagon, or when the owner gives the command to "hie on."

More than normal attention must be made to backgrounds when shooting dogs at work. Some field breeds blend far too well into certain environments—such as neutral-colored stubble and weed fields. Concentrate on photographing light dogs, when possible, against dark backgrounds and vice versa. Most of the time shoot with fast shutter speeds and large lens openings. But for a change of pace, it is also possible to do the opposite—to shoot with a fairly slow shutter speed and small lens opening for a special effect. Swing (or pan) the camera with the moving dog. This will blur the action, but give the impression of great speed.

Any of today's cameras will take excellent dog photographs, but as for other outdoor subjects I prefer the 35mm single-lens reflex because of its compactness and ease in handling. For portraits I use Kodachrome II film; High Speed Ektachrome for action. All the black and white pictures are from Tri-X.

Outdoor adventure photography is my business and I've traveled far to shoot everything from tigers to tarpon fishermen. But some of the most rewarding pictures in my files are of the friendly family beagle in my own

Being ready with camera in a duck blind rewarded author with this unusual shot of Blackie, a Labrador retriever, just after he had brought back a duck in icy water.

backyard. Hunting dogs are excellent photography subjects the year around. And much of the material presented here for dog photography applies to photographing any other animal pets, wild or domestic.

PHOTOGRAPHING WILD ANIMALS

An outdoorsman can take his wild animal photography seriously or casually. He can go afield expressly to shoot wildlife pictures or he can just snap pictures as opportunities are presented. It isn't unusual, however, that the very casual cameraman becomes completely absorbed by his photography, and soon finds himself concentrating on animal pictures.

Keep in mind that anywhere in the outdoors—on almost any kind of hunt-

ing, fishing or camping trip—you are certain to encounter at least some animals. Often the same camera you use for other pictures will take interesting pictures of this wildlife. All that you need is to keep the camera handy, loaded and ready to shoot.

While fishing on a lake or canoeing on a river anywhere in Canada or the northern United States, it's very likely you'll run into a moose along the way, perhaps even swimming nearby in the water. A quiet boatman may have the

To reach out for caribou, mountain goats or other animals in rugged country, a high-powered telephoto lens is the best bet. This party of hunters in British Columbia stops to shoot caribou on nearby mountain with Leica M3 and 400mm Kilfitt lens.

best chance of all to get close to animals in the wild. Other species often seen near water are raccoons and otters, beavers, muskrats and deer. Watch for them. Once when I was fishing the Firehole River in Yellowstone Park, a pair of huge bison bulls strolled toward the water's edge and bedded down there. That was a rare opportunity for pictures of an angler in the foreground with animals in the background.

Never overlook the smaller animals, such as squirrels, which may freeload around campsites. If at first they seem too shy, small tidbits of bait may bring them closer. Baiting, in fact, is a technique which any wildlife photographer can use. Food placed day after day in the same place will eventually attract squirrels, oppossums, foxes, raccoons and cottontails. It is surprising how many of these creatures live on the fringes, or even inside, city limits.

Although a casual wildlife photographer needs little or no special equipment, a serious cameraman will need a few accessories. A telephoto lens is most essential because it is difficult to approach even the tamest wild animals close enough to use only a normal lens. Keep in mind that wild animals behave more naturally when they are not approached too closely by humans.

HINTS ABOUT EQUIPMENT

Without a doubt, the most versatile camera for wildlife photography is the 35mm single lens reflex. The different kinds of telephoto lenses available to use with these were discussed in Chapter 3. Of all telephotos my own favorite is the Nikon 500mm mirror, in combination with a Nikon F2 with motor drive. Although somewhat heavy, the unit is compact and fast to focus (a great advantage). One can photograph subjects as close as 13 feet and also retain detail of large animals photographed as much as 100 yards away.

Especially in animal photography, it is necessary to hold any telephoto lens perfectly still when filming, and to use the fastest possible shutter—up to 1/1000 second if the exposure permits it. Whenever possible, use a solid rest, a tripod, clampod or unipod, rather than hand-hold a long telephoto lens. The longer the telephoto, the more it magnifies camera motion and results in fuzzy pictures.

Many wildlife photographers like to mount their camera and telephoto combinations on gunstocks for faster aiming and shooting. Some commercial stocks are available, but most are custom-built to suit an individual's own needs. I personally do not prefer these stocks and see them only as an extra weight to lug about. But there is no denying that some excellent animal photos have been made by gunstock fans.

No matter what equipment is used, the same attributes which make the best hunter also make the best wildlife photographer. All the stalking skills, all the patience, care, caution and knowledge of animal behavior which go into successful hunting with a gun will also pay off when hunting with a camera. The main difference is that when armed with a telephoto lens, you will have to approach much closer than with a gun. At the same time you must be concerned with focusing and exposures while making the approach—so know your equipment well before you start out.

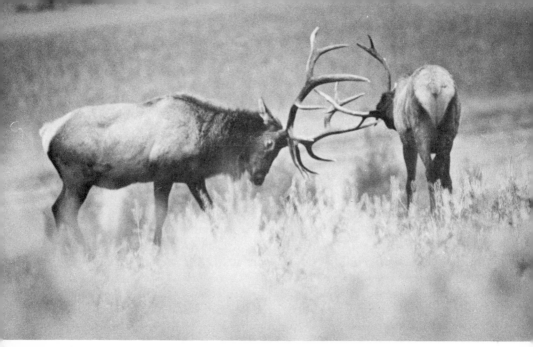

A rare shot of bull elk battling in Yellowstone National Park, Wyoming.

Long focal length lens made this shot of zebra possible. Backlighting helped round out the animal's features.

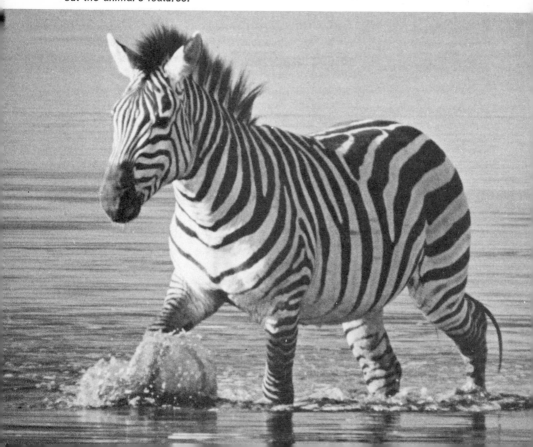

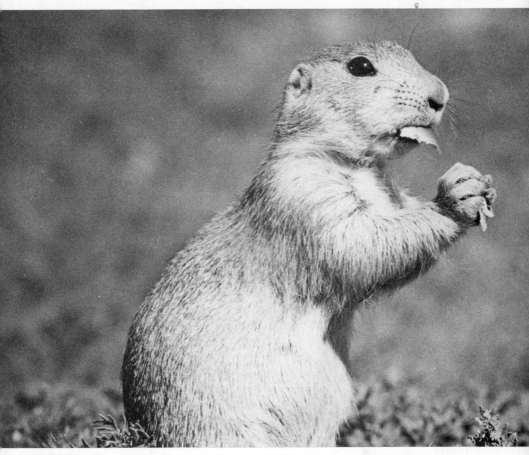

Bait tidbits enticed this prairie dog into view. Telephoto lens is essential here to bring animal up close and diffuse background with short focal length.

HINTS FOR PHOTOGRAPHING GAME

A good knowledge of animals you intend to photograph cannot be over-emphasized. Here again the skills of a gun hunter (or of a capable field naturalist) are important. Watch for tell-tale signs: tracks, trails, droppings, rubbed spots on tree trunks, dens, browse lines, bits of fur on thorn bushes, etc.

Assume that you want to photograph deer. The first step is to find the spots they frequent. Look for well-worn runways; deer tend to be creatures of habit and use the same trails and crossings day after day, even year after year. If hunting in autumn, check out forest floors which are littered with acorns or beechnuts, or look for abandoned orchards of ripe apples which are irresistible delicacies for whitetails. Keep in mind that deer (like many other animals) tend to be nocturnal and are therefore most active early and late in the day. Those are the times of day to concentrate your efforts.

Once the deer are located, you have the option of playing the waiting game, on a stand, or of stillhunting and stalking—the same options open to

a gun hunter. For a photographer, the waiting game is usually best. I suggest you build a blind or hide beside a busy runway. Or better still build it in a tree overhead because deer (like many other game animals) seldom look up to check for possible danger. The blind should be comfortable in order to make long waits more bearable, and it should be solid enough so as not to creak under movement or pressure.

The best places to photograph animals are in the national parks and monuments, in state parks and on some of the national wildlife refuges. Here animals are not hunted because they have become accustomed to people, and they are more tolerant of photographers. But even in these places, photographing animals is not simple. Here, too, you have to work for your pictures.

Most of the time it is better not to approach an animal quickly or directly. One September in Yellowstone Park, I was watching two bull elk sparring in a grassy meadow about a hundred yards from the road. They were bugling, pawing the turf, and beginning to lunge at one another in what promised to be a rare and savage scene. The bulls paid absolutely no attention to me. Suddenly a car stopped on the road and another photographer ran up and shouted, "Hey, what's going on here?" The elk turned and evaporated into the bush.

Most of the time I find it best not to try to stalk an animal unseen. It is far better to stay in full view of the target, and approach slowly, at an angle—almost never directly. Make no sudden sounds or movements. Try not to look at the animals or even to show any interest in them. It is surprising how well this technique can work, even on very shy species.

Even camera noise can occasionally spook a wild animal. Such noise is a drawback of some reflex cameras, which make an easily audible "plunk" when you trip the shutter. This sound doesn't faze some animals, but others hear it as a threat. One day I'd worked my way close to an antelope near Wind Cave, South Dakota. The animal was grazing, head down. When I had sharp focus, I whistled. The animal looked straight at me, still unalarmed. I snapped the picture, the shutter on my reflex making the usual "plunk". I might as well have stung the antelope with a red-hot pitchfork. The last I saw of it was its white rump retreating toward Montana.

Some animal photographers use extremely complicated devices to get animals on film and these result in many of the excellent and unusual wildlife pictures you see. Baiting is a device used for filming such nocturnal animals as the big cats and other carnivores. Either live or dead animals are used to bait the cats while almost any kind of garbage, from fish entrails to table scraps, honey, sweet anise, and fish oils will attract bears. Peanuts, baked goods, grain, and sunflower seeds attract the rodents.

Sometimes complicated automatic devices or trip wires connected to cameras and speedlights are attached to the baits so that when an animal grabs the bait, he photographs himself. Of course, it is necessary to locate the camera and light inside of a weatherproof shelter if it is to be left outside overnight.

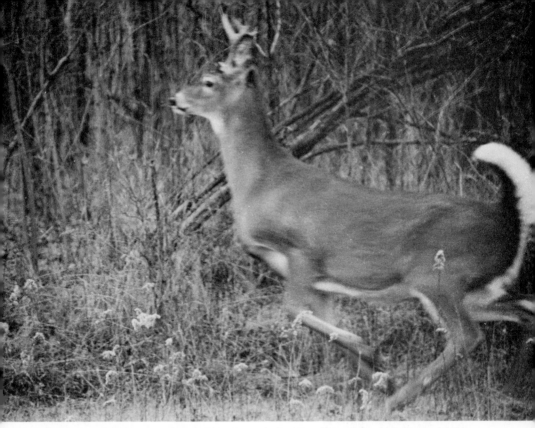

Blurring in wildlife pictures can show the speed and agility of the animal, as in this shot of whitetail deer.

A good illustration of the use of trip wires was demonstrated by cameraman Tom Hardin in photographing the elusive deer near his home in Michigan. He knew that a small herd was using a certain balsam swamp to rest and bed down during the day. They would come outside to browse only at daybreak and at dusk. Since there were three main well-used trails leading from the swamp, Tom knew what routes the deer would take. One afternoon he simply set up cameras and lights with trip wires along two of the trails and then sat in a blind beside the third. Eventually he had photos from all three places.

REPTILES AND AMPHIBIANS

These cold-blooded creatures present similar situations to a photographer as those discussed earlier. But because they are relatively slow-moving, snakes and turtles can often be caught and placed exactly where you want them for a picture. The cameraman's main concern is to place the reptiles in a natural setting and to use the correct exposure. It goes without saying that care should be used with the more dangerous or poisonous species. This is the time to use a telephoto lens and wear leather boots.

Frogs and similar amphibians present special problems because they are inconspicuous in their environments. They must be photographed at close range, and this calls for close-up accessories. Since it is much easier to find

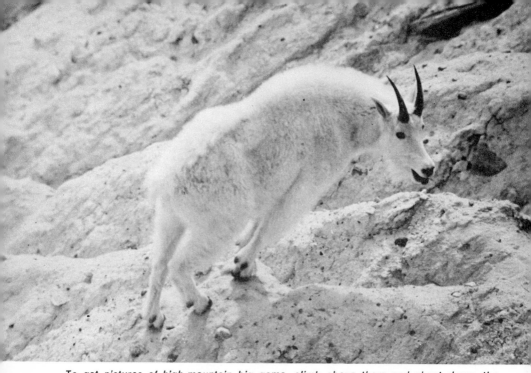

To get pictures of high-mountain big game, climb above them and shoot down, the technique used to get this fine Rocky Mountain billy in Jasper National Park, Alberta. Or, if possible, photograph them from below to get them against the sky.

Turtles make interesting subjects for the outdoor photographer, and they are relatively accommodating. This musk turtle by Walter Lauffer.

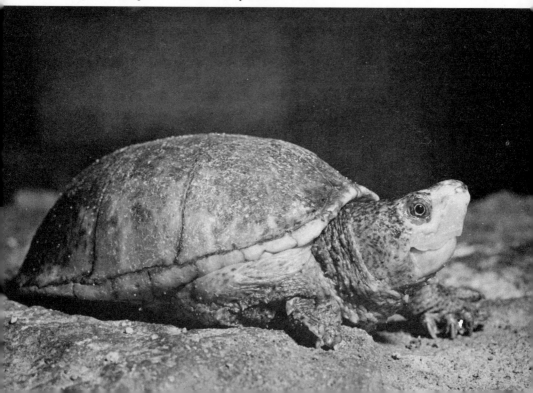

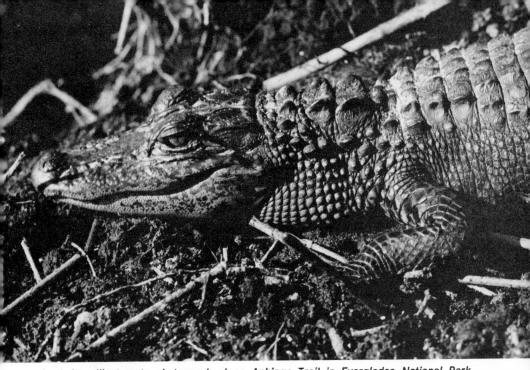

Look for alligators to photograph along Anhinga Trail in Everglades National Park. Back and side lighting are important to consider in all animal photography.

Photographer shooting aquatic life in a clear stream. His equipment is Leica M3, Viso-flex reflex housing and long lens, heavy-duty tripod, and waders. Note serious photographer isn't squeamish about getting tripod wet.

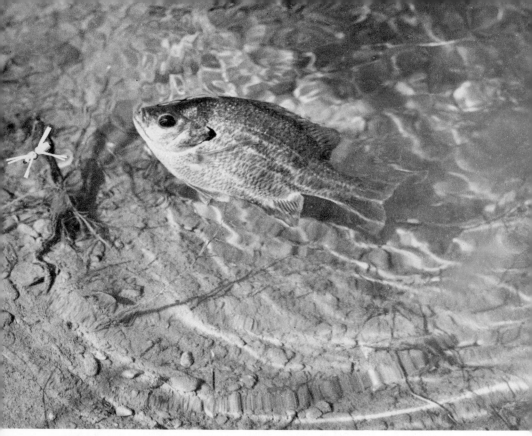

Patience was rewarded by this shot of bluegill in shallows of a Michigan lake. Nests of spawning bluegills were located beforehand, camera was arranged and preset, then a friend cast spider nearby.

these creatures at night (they're more active and noisy then), you will also need artificial light, probably waders, and either a pocket flashlight or dry battery headlamp.

Some of the most interesting pictures of frogs and their kin are taken in springtime during courtship, which is a strange event. The throats of some of these amphibians blow up to the size of the animal itself as they "sing" their love songs.

Photographing fish is mostly a pastime of the diver and underwater fan and we will cover underwater photography in another chapter, but occasionally it is possible to film fish from the surface in very clear, shallow water—for example, suckers, salmon, or alewives in their spawning runs. Approach the site cautiously, avoid reflected light striking the lens, and expose properly.

Some fish photography has been done from above the surface with glass-faced, open-topped waterproof housings which are inserted just under the surface. With a reflex camera inside, the photographer can look down and into the water—and not have to worry about reflection and refraction.

8 How to Photograph Birds

THE SUBJECT of bird photography is so vast and fascinating that it deserves an entire volume rather than a single chapter. Like animal photography, it is a hobby that quickly can become a mania—no doubt because birds are among the interesting and exciting creatures on the face of the earth.

Consider for a moment the great variations among the world's birds and you can see the compelling challenge that confronts a serious bird photographer. Some birds live on or in the water and others dig holes in the ground. Some dwell on polar icecaps. Some species never wander far from the nests in which they were born while others fly half-way around the globe during annual migrations. A buzzard, it seems, can fly almost forever and never beat its wings, but a hummingbird travels at over 150 wing-beats per second. Some birds can't fly at all while others zoom faster than an eye can follow. And what other living creatures are more brightly colored, more beautiful to see on color film as well as in life?

Men have gone to great extremes in time, toil, and expense to obtain good bird pictures. More than one bird photographer has lost his life in trying to make a significant picture.

One of the strangest incidents of all concerns the Maine conservationist who moved twenty-five square feet of earth twenty-five miles to a studio just because it contained a woodcock on a nest about to hatch. The man, John Stobie, found the nest by accident. He wanted to film the nesting bird which refused to flush even though he almost touched her. But the nest was in an impossible place to photograph and so, with friends, he removed the 5x5 feet of real estate, slid it into a bricklayer's mortar box, and loaded the whole works on a truck. The bird didn't leave the nest during the twenty-five-mile drive to the studio where it was photographed under bright studio lights. Afterwards, the turf, nest, and bird were returned to the woods, and soon the young woodcocks successfully hatched.

Photographing flushing ruffled grouse is one of the most difficult and challenging tasks—camera must be preset for aperture and distance, and at highest speed possible, unless you want to show motion. This one made with 35mm camera at 1/1000 second didn't stop movement of bird.

An American outdoorsman may also be surprised to learn that some of our most treasured natural wonders have been preserved and set aside because of bird photography. Early in the 1900s, for example, President Theodore Roosevelt set aside several bird refuges in Oregon because of the splendid bird pictures made there by Bill and Irene Finley.

Many outdoorsmen have shared a common disappointing experience when

first attempting bird photography. Charmed by a bird on the back porch or in a camp somewhere, many a man has grabbed his camera, aimed, and snapped. But chances are that on the developed film, the bird was little more than a speck, almost impossible to see. Therefore a telephoto lens is a necessity for most bird photography—at least for filming individual birds.

Many birds are neither shy nor particularly fearful of men, and on certain refuges and sanctuaries ordinarily shy birds lose some of their wariness. An excellent example of this is the spring-fed pond in the center of Castalia, Ohio, where wild waterfowl collect in early autumn and remain until early spring. These wild ducks, fresh from the northern flyways, have learned over the years that this is a haven. As a result it is one of the best places in America to take pictures of wild ducks at close range.

But most birds are not confiding enough to make picture-taking easy and that's why certain techniques have been developed for greater success. Blinds are very effective, and so is baiting. There are exceptions to the rule, but probably the baiting of birds is far more productive than the baiting of animals. Another effective technique is to shoot birds by remote control. A camera is set up firmly near a bird nest and the photographer, who remains some distance away, trips the shutter by remote control. The most experienced bird photographers often combine baiting with blind photography or baiting with a remote-control setup.

In North America there are two best times to shoot birds—in springtime and again in fall. During both periods the birds are most active. Springtime is also nesting time, an interlude when much activity is concentrated around nests and also when most birds lose at least some of their natural wariness. Birds busily preoccupied with nest building, courting, incubating, and feeding young pay less attention to humans with cameras. In addition, male birds have brighter plumage in spring than at any other time and this is no small consideration for the color cameraman.

Autumn is the period when birds gather in flocks for migration. It is also the time when certain species, especially the waterfowl and the other gregarious species, are most evident and easy to find by an untrained ornithologist.

PHOTOGRAPHING BIRDS IN SPRING

Let's go back to spring and discuss shooting bird pictures at that time. You have spare hours on your hands and birds have always fascinated you. How do you go about photographing the common birds you see every day?

The first step is to find them—or rather to find a nest site. One way is just to follow an individual bird's flight until it leads you to the nest. This is easy with most songbirds. Another way is to systematically search in bushes and thickets, in trees and meadows. The ornamental evergreens around suburban homes are good places to look.

It will save time, if you are serious about this, to do a bit of research beforehand. There are a number of excellent bird guides on the market which make identifying birds and finding their nests much easier. There is no

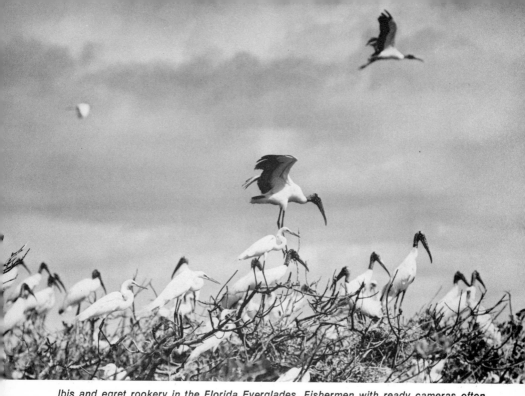

Ibis and egret rookery in the Florida Everglades. Fishermen with ready cameras often have opportunities for pictures like this.

Good photos of wild tom turkeys take careful stalking and telephoto lens. Contrast against background is important, too.

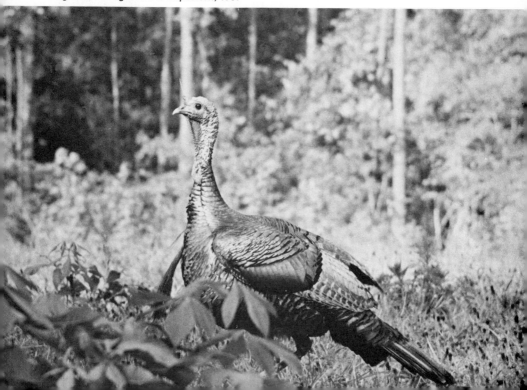

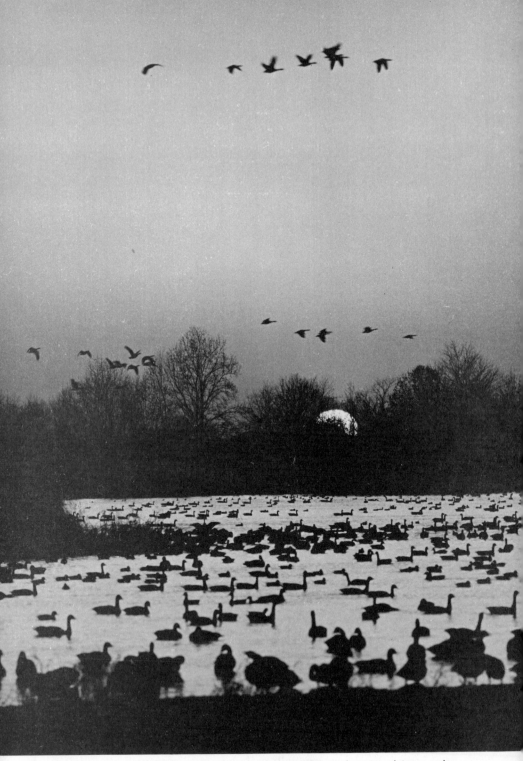

Sundown on a pond in Maryland. To get this photo, author took many pictures using a wide range of exposures to be sure. This one worked best.

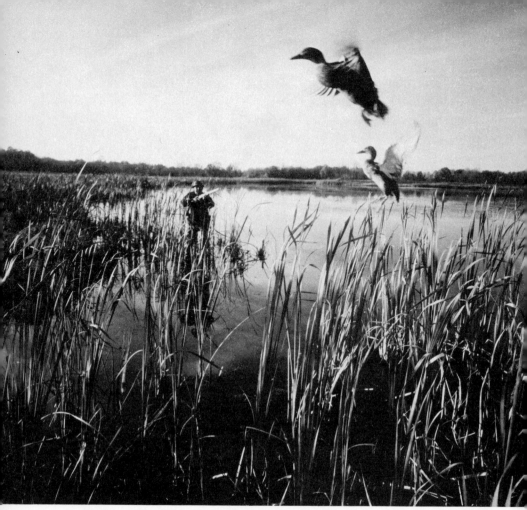

A photographer should develop knowledge of birds and how they will react, to get a shot like this scene of hunter flushing ducks in Midwest pond.

percentage in looking for a bluejay's nest where a bluejay's nest isn't likely to be. It is also a good idea to get acquainted with common bird songs. Singing is most often connected with courtship and nesting, and many neatly hidden nests have been found by tracing a bird song to its origin.

Once you have located a nest, no matter where it is, proceed cautiously. In the early stages of nest-building and courtship, birds are more likely to move elsewhere if they are unduly disturbed. The later in the process—as during the final stages of incubation and after young birds are hatched—the more tolerant the birds will be of people. A few can almost be touched before deserting a nest of nestlings.

Occasionally it is possible to photograph the birds and nest without a blind or remote-control setup of any kind. I've photographed the female mourning dove nesting in a frontyard evergreen from only a few feet away. I approached a little closer—gradually each day—until eventually she didn't mind my nearness at all. But far more often a blind will be necessary.

I've been extremely fortunate to have worked with Karl Maslowski, the Cincinnati naturalist and motion-picture producer whose bird photography must rate with the finest ever done anywhere. Much of his success comes from extraordinary patience, an unusual knowledge of his subjects, and great skill in building and using a blind. Although the potential bird photographer cannot duplicate these abilities, he can benefit greatly from Maslowski's general techniques.

How to Use a Blind

The first step is to place the blind a safe distance away from the nest. As the bird grows accustomed to it and shows no apprehension, the blind is gradually moved closer and closer until the cameraman is practically an intruder. In addition, when the birds are temporarily away from the nest, foliage and limbs are tied back or even trimmed away to improve the scene by allowing more light on the subject or eliminating obstructions before the lens.

Maslowski's basic blind is cupola-shaped. It is built of a framework of metal tubing and covered with a form-fitting piece of cemetery cloth. Olive-drab duck or burlap might do just as well. Slits are provided for using two cameras (one movie, one still) at a time. But the blind itself can be anything which completely hides the cameraman, and which isn't too incompatible with the surroundings. It can even be a small tent. Incidentally, this cupola blind is equally effective for photographing certain mammals, such as wolf, coyote, or fox pups around a den, groundhogs, badgers, or prairie dogs. It is also good for placement near a waterhole to film anything which happens to come along.

But all birds, and many of the most interesting species, do not nest near ground level. To photograph the herons and egrets in a rookery at Reelfoot Lake, Tennessee, Maslowski had to build a blind (plus ladder) ninety feet up in a cypress treetop. To photograph a bald-eagle nest near Lake Erie, he erected a steel tower on top of which he placed the cupola blind. The entire tower was moved closer and closer to the nest as the eagle became adjusted to it. Remember that overhead blinds are also excellent for photographing wild-life on the ground below.

Maslowski's efforts in photographing the eagle were rewarded; his pictures are of a quality and beauty seldom seen. And they were taken none too soon. The following year, high winds and the accumulated decay of the dead tree finally toppled the nest which had been used continuously by eagles for more than a quarter of a century.

Blind building is not an especially difficult chore, but there are a couple of facts to keep in mind. One concerns the weather. Several years ago, during an early attempt at bird photography, I found a red-wing blackbird nest beside a soggy lake shore and immediately built a blind nearby. The blind consisted of a green sapling framework covered with burlap (an excellent camouflage material) and dead marsh grass. When finished it was sturdy and inconspicuous, and I was very proud of it.

But I didn't figure on foul weather. During the first night a wild storm

Karl Maslowski (left) and friend show a blind of aluminum rods and cemetery cloth used for bird photography. Photo by Allan Kain.

Blind ready, Maslowski prepares cameras to go into field. Note two slits in blind, one for still, one for movie camera. Photo by Allan Kain.

Blind mounted on framework to photograph a hawk's nest in giant cactus.

The result. Effort that went into building platform obviously was worth it. Photo by Karl Maslowski.

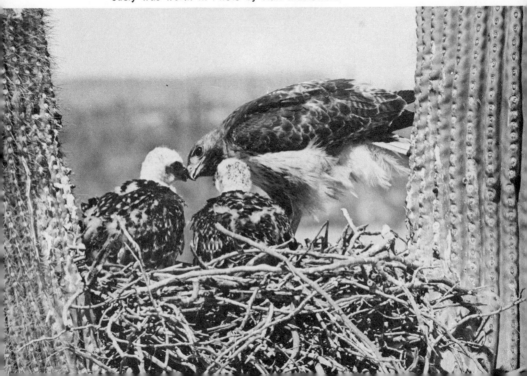

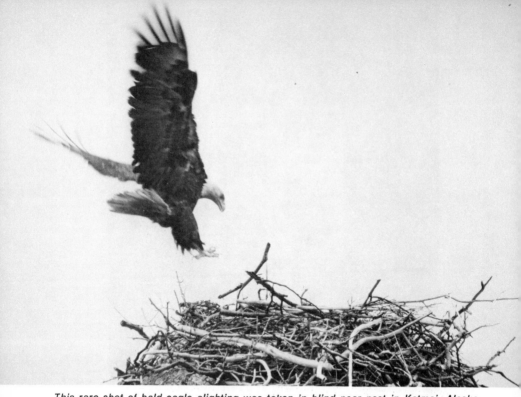

This rare shot of bald eagle alighting was taken in blind near nest in Katmai, Alaska.

A pit blind, dug in cornfield, was used to photograph these descending Canada geese.

broke and blew my handiwork onto the open lake. The lesson here is to anchor all blinds firmly in place whenever you leave them for more than a short period. The simplest thing to do in most cases is to drive stakes in the ground all around and then to run guy wires (or maybe manila ropes) from the blind to the stakes.

PHOTOGRAPHING BIRDS IN AUTUMN

Autumn is the time of year to shoot birds en masse. Often it's possible to locate birds just by driving around the fringes of lakes and ponds, potholes, creeks, and any nearby bird sanctuaries. Many good pictures of rafted ducks and water birds—and even of birds of prey—have been taken from the window of an automobile. More often than not, a photographer can approach closer to birds (and animals as well) in a car than on foot. I have even taken fair pictures of crows from a car window, and it's virtually impossible to approach within picture-taking range of a wild crow when on foot.

A good technique is to try to spot the birds from fairly far away. Binoculars can help here. Figure what the range will be at the closest point you will be able to reach. Preset your camera (both exposure and focus accordingly) and then drive as close as you can go. Have the nearest window rolled down. Now—stop, aim, and shoot without delay. If the birds remain unalarmed, check the focus carefully and shoot again. If they're still unalarmed, try to get closer on foot. If the birds fly immediately when you open the car door, nothing is lost because you should already have something worthwhile on film.

I have made some good waterfowl pictures by using hunting blinds after the shooting season closed. Ducks and geese are fairly easy to attract with bait, and the baited blind is most effective. Late in the year especially, corn, millet, and waste weed screenings (which you can obtain free from any feed mill) will work wonders.

A waterfowl blind is also a good spot from which to make pictures of birds in flight. This isn't the easiest kind of bird photography, but the results are among the most exquisite and most satisfying. Generally the best results have been obtained by photographers using cameras with telephoto lenses mounted on gunstocks.

Probably an experienced wing shooter would have the advantage in this type of photographing because finding the target, swinging on it smoothly, and then following through are absolutely necessary to success—just as they are in upland gunning with a shotgun. You must remember, though, *not* to "lead" the bird! In photography you must also try to maintain proper focus at the same time. Obviously that isn't easy, but one way to get around it is to pre-focus and wait for the bird to fly into the zone of sharp focus. Always shoot at the fastest shutter speed possible.

Cameramen aboard saltwater fishing boats should never pass up the splendid opportunities to shoot seabirds which frequently hover astern. Some gulls and terns can even be attracted to bits of cut bait thrown up into the air. Still

Birds can be photographed en masse in autumn, and a hunter adds impact to this kind of scene as well. These are geese over grasslands near Fort Albany, Ontario.

other birds will gather at the end of the day to feed on entrails while you are dressing fish. Many of the Florida pelican pictures are made this way around busy fishing docks.

PHOTOGRAPHING BIRDS IN WINTER

Bird photography can be a delightful hobby all through the winter. It can, in fact, turn bitter and dreary days into happy, suspenseful events.

The easiest way to shoot winter birds is to build a bird feeder near a convenient window, while keeping the position of the sun in mind. Sunlight isn't necessary for this shooting, if you have a flash or a speedlight, but it is preferable.

Depending on where you live and which birds winter in your vicinity, you

Close-up of North American wood duck, one of the most beautiful birds on earth.
Photo by Karl Maslowski.

can use many kinds of baits with great success—peanut butter, suet, bacon, slices of apple, raisins, cracked corn, or sunflower seed. You can place these tidbits in an elaborate bird feeder or you can simply hang a strip of suet on a limb and watch the antics of bluejays and their friends trying to tear it away.

It may take several days for birds in quantity to "discover" the bait, but eventually they will, and then you are ready to start shooting. More often than not you will be able to accomplish other chores around the house and only turn to photography when there is activity at the bait—or when some rarer than usual species arrives for refueling. Sometimes the scene around a feeder is so interesting that you forget about photography.

REMOTE-CONTROL CAMERAS

Many fine backyard photos can be accomplished by remote control—by a photographer stationed in the warmth and comfort of the house. When this is planned, it is a common trick to set up a dummy camera near the bait or feeder so that the birds get used to it from the very beginning. When the real camera is substituted, they never know the difference.

The effectiveness of a remote-control camera and of its operation depends

Focus is extremely critical when strong telephoto lens is used, as in this photo of bobwhite. Area of sharpness within depth of field is little more than an inch, as can be seen by sharply focused head and out-of-focus side feathers and background.

entirely on the ingenuity of the cameraman—just as we pointed out in the chapter on animal photography. The simplest way of all, possible with some cameras, is to tie a thread or section of light monofilament fishing line to the shutter-release lever and pull it at the right time. There are too many different types of shutters to discuss all of them here, and the photographer will have to devise something for his own particular use.

A simple and inexpensive air-release will prove satisfactory at least 90 percent of the time. These devices use a rubber bulb and vinyl tubing (*not* rubber tubing—it stretches too much) to set off the camera from as much as a hundred feet or more away. They screw into the cable-release socket and will fit practically all cameras. Electric eye trippers are also available on the market, though these devices are not too difficult for mechanically inclined outdoorsmen to build at home.

One objection to remote-control photography has been that only one exposure could be made at a time. After each exposure the cameraman had to go to the camera, wind to the next film frame, and perhaps re-cock the shutter mechanism. This is highly disturbing to birds and usually disperses them. But now a number of cameras are able to do these things automatically. They're expensive, but no doubt worth it to the serious cameraman in bonus pictures he wouldn't have had before.

9 Photographing Plants and Trees

WHEREAS MUCH of outdoor photography is concerned with recording a specific event or scene, plant photography gives the cameraman a greater chance to express himself artistically. He may, for example, derive great pleasure from composing a picture in which the twisted limbs of a bristlecone pine are the main interest. Or he may film the intricate pattern formed by a strip of white bark peeling from the trunk of a canoe birch. Another especially pleasing shot might be the spongy nose of a morel mushroom poking upward through the leaf litter on a forest floor. Pictures like these are satisfying to make, even if no one else ever sees them.

PHOTOGRAPHING FLOWERS

The most satisfying way to shoot wildflowers is at close range. It's tempting to take pictures of fields or meadows full of flowers, but unless the blooms are extremely dense, the results are often disappointing. A close-up of bluebells with beads of dew on the petals is far more striking than pictures of clumps of bluebells scattered along the margin of a brook.

The best flower close-ups result from observing the following rules: 1) Use a tripod and a cable release to keep the camera steady. 2) Use a close-up attachment or tube or bellows extension. 3) Use a small lens opening for maximum depth of field, unless you wish to blur out the background. 4) Be sure to focus accurately. 5) Correct for parallax where it is necessary.

Some very artistic and unusual effects result from blurred flower close-ups; but unless this is desired, sharp focus is the most critical factor of all. With some cameras you can focus by looking through the lens. When using other types, it will be necessary to actually measure the distance from lens to flower. Accurate measurements can be made with a roll-up steel tape, a carpenter's folding rule, or a string knotted at measured intervals.

An alternate method is to use a focal frame. This is a simple rectangular frame of stiff wire affixed to the camera at a certain distance from the lens. The distance, which may be from twelve inches to about thirty inches, depends on the type of close-up device being used. The flower or object to be photographed is then placed inside, and on the same plane as the wire frame.

The impact and beauty of any flower close-up comes from the bright color and delicate shape of the flower. Sharp focusing will assure that the delicate shape will not be lost, and proper exposure will accurately render the color. Keep in mind that close-up exposure with close-up lenses is the same as for any other subject under similar light conditions.

Remember also that backgrounds are most important because they can either add or detract from the picture. For tall plants, tilt the camera upward and try using the sky as a background. Pieces of colored cardboard or cloth can provide unique backgrounds. For short, light-colored plants, try to have a dark background—and vice versa. For low-growing flowers, try aiming straight down for a bird's-eye view. If the flower is extraordinarily tiny, place a shiny new dime beside it for comparison.

A tinfoil-covered reflector, a white card, or even a newspaper will throw light into deeply shadowed areas where there is great contrast on the flower itself. Contrast may be desirable or undesirable, depending on how you use it; as I pointed out before, this is your chance for artistic expression.

A supply of string in your pocket can be very helpful in tying aside other flowers you want to eliminate from your composition, and a small piece of canvas or a cushion is handy to sit or kneel on while composing the picture.

Make it a point to look for rare flowers to add enjoyment to the photography. A good book on wildflower identification will be very helpful.

More often than not, mornings and evenings are best for flower photography because it is calmer then. Winds that rise as the day progresses can be a real nuisance because the subjects are so easily shaken. The less movement, the better. Sometimes it's possible to place a sheet of clear plastic behind the flower as a shield against the wind. If properly done, it will not change the background or give an undesirable reflection.

Following are other points worth considering in flower photography:

1. For extra sparkle, sprinkle a few drops of "dew" on the flower with an atomizer or a child's water pistol.

2. Back-lighting creates extra brilliance in color slides. Keep the background darker than the flower. Contrast of color also enhances the effect.

3. Contrasts enhance color—try small, bright flowers silhouetted against masses of deep-green foliage.

4. A solid field of flowers, filling the whole picture, has a powerful color effect.

Morel mushrooms are familiar (and welcome) sight to American outdoorsmen. In close-up such as this, very small aperture of f/16 was necessary to keep main objects and background in focus.

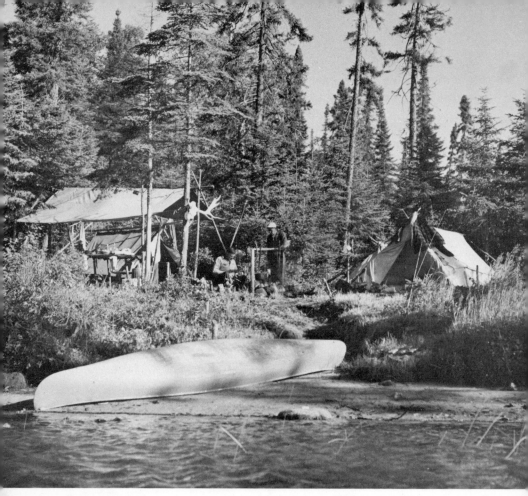

Back away from camp to include background trees. This is a good way to set the mood and show rugged wilderness of the camping area, as in this scene on Yesterday River, Ontario.

5. Extreme close-ups are most easily made with a single-lens reflex camera with a close-up lens or extension tube added.

6. For close-ups in shady places, with daylight color film, use a blue flash-bulb for "fill-in" light. Reduce and soften the light of the bulb by stretching a handkerchief across the reflector. A card covered with bright metal foil can also be used to reflect sunlight into shady spots.

7. Autumn leaves are good subjects for color slides and prints to supplement your collection of flower close-ups. Don't forget fruits, nuts, toadstools, lichens, bright berries, and even colorful fresh vegetables.

8. Back-lighted blossoms provide a pleasant background for people. Use a blue flashbulb or reflector to put light into the shadows.

9. For picture-taking practice, visit a conservatory or greenhouse—there is no wind, plenty of light, and beautiful flowers the year round!

10. If a tall flower sways too much to permit a sharp picture, just tape a slender green stake or wire behind the stem.

PHOTOGRAPHING TREES

Except to shoot pictures of such unusual trees as the giant sequoias of California, or the banyans and baobabs, photographers do not ordinarily collect tree pictures as they do flower pictures. Yet trees can enhance many pictures, often when they are subordinate to the main subject, although a maple wearing the scarlet cloak of autumn can demand attention above any other object in a color picture.

Since most trees in this country are deciduous, autumn is the best season for tree photography. A second choice would be springtime, when some trees are in blossom and every forest displays a variety of shades of green. I have never been able to take all the autumn color pictures I wanted to. Sadly, the peak color season is too short to cover enough ground; but in recent years I've devised a means to accomplish a little more shooting. My method calls for carrying a notebook and pencil all year long and listing places which will make rich autumn scenes. On occasion I have photographed the same scene from exactly the same place in springtime just to show the remarkable changes in nature. But listing specific places beforehand saves time and effort when fall color is finally at its peak. Of course, this requires a knowledge of trees.

Few rec vehicles are really attractive. When photographing them, try to use a natural framing, as here, when possible.

Here trees furnish a frame for solitary fisherman on a lonely lake in the Canadian Rockies. Trees in foreground also add interest, emphasizing ruggedness of scene.

All species do not turn color and many turn the wrong color. It can be disappointing to return to a scene in the fall, only to find the main tree in a planned picture is dull brown rather than golden.

Because of their graceful patterns, trees serve as ideal frames for outdoor pictures. When the tree is in shade and shows up as a silhouette, it makes a particularly attractive frame. A lovely effect also can be captured when the foliage is brilliantly back-lighted. Trees front-lighted in bright sun are least effective of all.

The bare trees of winter offer the photographer a chance to free his imagination. Go outdoors after an ice storm or a heavy snow and see some of

Reflections of trees in water of this Texas lake are an enticement for anyone to photograph. Interest is added as branches and their reflections frame the fishermen.

Tall, slender tree in foreground adds depth and interest to this scene of Maligne Lake in Jasper National Park, Alberta.

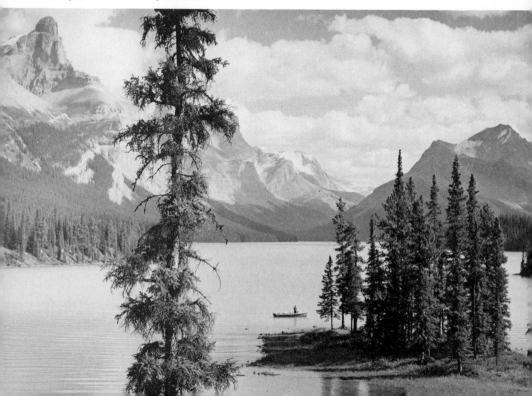

the strange and lovely compositions which form in your view-finder. Try also to use the leaves and fruits of trees in composing still lifes.

A final word about photographing forests: Photography in deep forests or under the canopies of trees is best done in muted, somewhat dull light. On bright days the contrast between dark and light places may be too much to cope with, though this struggle between lights and darks can be dramatic— for example, a shaft of early-morning sunlight falling on a steamy jungle floor. Keep in mind that masses of green foliage have a tendency to appear dark in a picture. For black/white film, a light-green filter offers some relief.

Plants, from tiny maidenhair ferns to huge elms, are part of the outdoor photographer's fascinating world. Place them wisely in your pictures.

10 Aerial, Underground, and Underwater Photography

AERIAL PHOTOGRAPHY

NOWADAYS OUTDOORSMEN frequently travel by plane—perhaps the first leg by commercial airliner and the last by float plane to reach a remote outpost. It is possible to take pictures all the way from an exciting viewpoint.

Some of the best aerial subjects are the outstanding terrain features— mountain ranges, necklaces of lakes, rivers, large reservoirs, coastlines, and clouds. For the best view of these features, select a seat in front of or well behind the wing. When shooting from these positions you can either use the wing and plane motors as a frame or omit them altogether.

Aerial photography presents a few unique problems, but they're not difficult to solve. For the best results you must have an absolutely clear day, not necessarily cloudless, but rather a day with no mist, haze, or fog. The clear, bright period following a storm or rain is usually very good. Of course, the traveling outdoorsman cannot schedule his trips to coincide with the best weather; as a result, haze becomes a nuisance.

Haze in the atmosphere tends to give a bluish cast to color film. This cast increases with altitude and is greater in oblique than it is in vertical shots. That means you should sit on the shaded side of the plane where the sun will be behind the camera. A haze or skylight filter will also eliminate some of the blue with daylight color films. You can also use artificial-light films with a conversion filter. Some photographers prefer the results you get this way, and it may get rid of more haze-effect.

With black/white films, haze greatly reduces contrast and makes it difficult to see detail on the finished print. This nuisance can be reduced somewhat by sitting on the shaded side of the plane and by using a yellow, red or orange filter.

Next to haze, motion is the aerial photographer's greatest consideration.

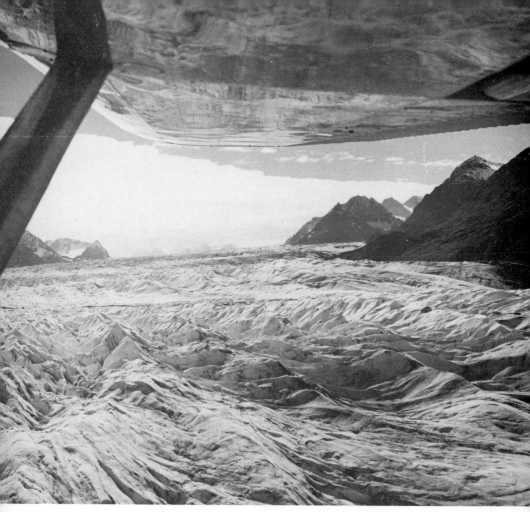

The best aerial shots come on clear, haze-free days. The reflections on underside of the wing help this picture of rugged Tazlina Glacier, Alaska.

The best advice is to use the fastest shutter speed on the camera. Since all aircraft vibrate badly, never rest the camera on any part of the plane's window. Instead hold it firmly in your hands and try not to let any part of your body above the waist touch any part of the aircraft.

Generally, exposures will be the same in the air as for pictures taken on the ground in the same light. It is still a good idea to increase the lens opening as the altitude increases to avoid an underexposed look to color film. Figure on increasing a half stop between 2,000 and 4,000 feet. Make it a full stop above 4,000 feet.

Sometimes on trips to wilderness areas, you may wish to film animals or herds of animals on the ground. If so, remember that it's doubly essential to use the fastest shutter speed and to pan *with* the animal as you overtake and pass it. Whenever possible try to shoot through an open window (this is possible on many small planes). The next best bet is to thoroughly clean the

glass before take-off. Shooting through the windshield is usually film wasted because of the curved glass surface and the propeller blur.

Occasionally on dull or cloudy-bright days you can get striking aerial scenes by shooting into the sun. At such times, rivers become ribbons of silver and lakes have a molten look. Other geographical features make strange patterns in your view-finder—so be on the alert for them.

UNDERGROUND PHOTOGRAPHY

Eventually many outdoorsmen find their way underground—into caves and caverns. And it's no wonder, because caves are like magnets to adventuresome people. I do not refer especially to the commercial caves which are lighted, paved, roped off, and generally garish attractions, but rather to natural underground passages where a man may explore on his own.

The cave photographer needs a number of important accessories: a flash unit, protection against moisture and dampness for all his gear, and probably a tripod. He should also carry indoor-type color film. Because of the cramped

Pictures from the shaded side of the plane are usually the most successful. Enclose part of the plane for orientation and perspective. Use a relatively fast shutter speed and hold camera as steady as possible. This is Elephant Butte Reservoir, New Mexico.

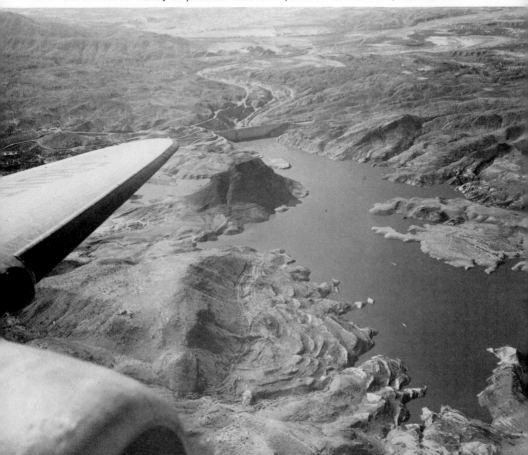

quarters in many caves, a wide-angle lens will allow composition which isn't possible otherwise.

The main attractions in most caves are the strange geologic formations—the stalactites and stalagmites, the encrustations, underground pools and rifts. Of course these will be your main subjects. Ordinarily, wildlife isn't abundant in most caves, although some are best-known for their great populations of bats. The following tips are worth keeping in mind for any cave explorers:

1. Use your artificial light where possible to side- and even back-light the strange formations. This will give more depth than a flat, front-lighted picture.

2. Get companions in the pictures—if only as foreground silhouettes. If they are carrying ropes, climbing gear, or digging tools, be sure to show these.

3. Try varying the exposures, because the regular guide numbers may not prove reliable in cave surroundings where walls are of different textures and have different reflecting qualities.

This Canon F-1 is easily, and safely, encased in an Ikelite underwater housing unit. Accessories that cannot be side mounted for underwater use may be enclosed in a wide selection of versatile housings.

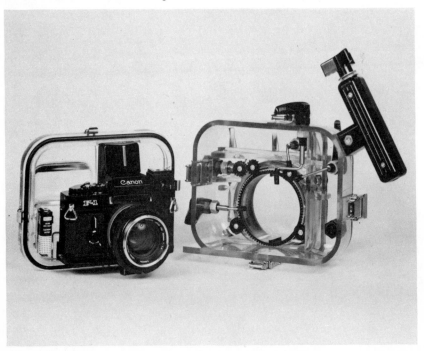

4. If it's a bat cave, you might get highly unusual shots of bats flying out at sunset. Or pictures of clusters of bats clinging to cave walls. Incidentally the little mammals are harmless unless manhandled.

5. Get pictures of people doing things inside the caves—looking at old paintings or pictographs on the walls, eating lunch, descending into deep chambers, drawing a map, checking equipment, using a Geiger counter, examining a bit of unusual rock.

UNDERWATER PHOTOGRAPHY

This subject is so complex that it deserves vastly more than this brief treatment; but here we'll aim mostly at the typical outdoorsman who only rarely would take a camera underwater, or who might do so some day in the future. In either case, there is a stunning, thrilling, completely different new world beneath the sea waiting to be enjoyed and photographed.

This one point should be made clear in the beginning: There is no magic to taking good pictures underwater if you are able to do so above water.

Obviously, it's necessary to be able to swim and move about underwater. Besides the physical ability, that includes using diving gear—either a simple face mask and fins or scuba equipment—for staying down longer, certain camera accessories are also necessary: first and most important being the underwater housing for your camera; and second, an underwater flash unit.

There are three kinds of camera housings for use in the water: the soft plastic bag, rigid plastic or plexiglass housing, and metal housing. All three make it possible to operate the camera—set the exposure, snap the shutter, wind the film forward—from outside the housing while the camera remains dry inside.

The soft plastic bags are made of heavy-gauge vinyl, but their use is limited and not many experienced marine photographers use them. Rigid housings made from $3/8$- to $1/2$-inch plexiglass are satisfactory to depths of about 100 feet or more, but they are considered fragile. It's an easy matter to build your own plastic housing, especially if a plastics dealer can cement up the basic box, getting perfectly tight and strong seams, and the sides parallel. Materials alone run about $20, and perhaps $35 or $40 with the basic fabricating. Building your own will, however, eat up an unbelievable amount of time, and if this is scarce you may be better off to buy a housing for your own particular camera. The best housings nowadays are those of foundry-cast aluminum, precision machined to fit individual cameras. These can take rough handling and most are guaranteed for use to 200 feet in depth, but they often cost more than the camera you put inside.

Certainly the solution is to make the camera itself waterproof, and this is the trend in today's diving cameras. These can also be used without qualms in rain or snow, duststorms, blizzards, at the beach, and on and around small boats. The Nikonos is the latest to make its appearance, and is a nicely designed and well-thought-out piece of equipment. It is small and light, fast

The Nikonos II is a waterproof 35mm camera with a die-cast metal body for use under water in depths to 160 feet. Contrasting-colored rubber caps are provided for focus and aperture knobs, permitting easy visibility. It uses both the Nikkor 35mm f/2.5 lens and 28mm f/3.5 lens. The camera can also be used with the Nikkor 15mm f/2.8 lens and 80mm f/4 lens.

to operate and easy to load. It does not have either range-finder or reflex focusing, but with the standard 35mm wide-angle lens you can successfully guess-focus on any subject over five feet or so from the camera. There is a depth-of-field scale that changes as the diaphragm is changed, so you can see at a glance what zone is in focus and make settings accordingly. This is a lot easier to do than to describe.

All the problems of composition are the same as in ordinary photography, although water density imposes some restrictions. You shoot scenes, people and action as you would above water.

Exposure requires more discussion. Underwater exposure meters are available and very useful, but a meter becomes another odd item to lug around or to tie to a belt. If you're building your own case, consider mounting a meter inside along with the camera. If your camera has a built-in or clip-on meter, design the case so that it can be used. Either way avoids carrying an extra piece of gear and lets you keep track of light changes.

Many photographers base their exposures on light above water, increasing it according to the depth and clarity of the water. This is strictly trial and error, but it's possible to give a fairly accurate starting point.

Let's say you are using a fast black/white film (which is good to start with) and you are diving in the Gulf Stream on a bright day. Above the surface your correct exposure would be 1/250 second at f/22 or even f/32. Ten feet deep it would be 1/250 at about f/18 or f/16. Twenty feet down you would have to open the lens to f/14 or f/11 and thirty feet down it would have to be f/9 or f/8. A rough rule of thumb, therefore, would be one f/stop per ten feet of depth in very clear water.

Karl Maslowski uses a sealed housing to shoot pictures underwater. His camera is inside. Photo by Allan Kain.

Scenes like these are possible for the swimmer who goes underwater with his camera.
They are a sawfish and giant sea turtle (opposite page), and dragonfish.

Unless a photographer confines his shooting to very clear portions of the ocean, or to the rare, clear freshwater areas, he will have to allow more and more exposure the deeper he goes. Probably the main difficulty in underwater photography is the lack of clarity caused by the silt and dinginess found in too many waters.

Still, it's surprising how much light actually penetrates the surface. The light that doesn't penetrate is reflected away—and more is reflected away by a choppy surface than by a smooth surface.

Following are important tips for anyone who plans to take a camera underwater:

1. Make sure your housing is waterproof. Place the camera inside the housing and then put it in a tub for thirty seconds—no more. Take it out and check for leaks. If none exist, replace it for a longer period. Only after you have tested a housing progressively is it ready for actual shooting.

2. You lose light the instant you take a camera below the surface. The farther you go down, the more rapidly light evaporates.

3. If you have trouble steadying yourself enough for shooting, add lead weights to your diving belt. Properly balanced with the right amount of weights, you will be able to hang in mid-water without paddling to keep from rising or sinking. This is much steadier, and a necessity for careful shooting and the best possible pictures.

4. Get close to the subject. Distant objects tend to fade into the background. For this reason, use a wide-angle lens if you possibly can. The ultra-wide angles, however, will show distortion at the edges. This can usually be cropped out, but take some test shots before any important dive.

5. Keep a record of your shooting. Record the light available, the wind condition, water clarity and the exposures during later filming.

6. Use a fast enough shutter speed to stop movement—as of fish and other divers. Too many underwater pictures, otherwise good, are ruined either by camera or subject motion. The same principles apply here as in ordinary photography.

7. In very dirty or cloudy water, use only short focal length (wide angle) lenses to get closer to the subject and shoot through a minimum of water.

8. Filters are necessary for the best results in either black/white or color. Use reds to compensate for excessive blue with color films, and magentas to correct for green. Red, orange, or yellow will help with black/white but may make the blue background come out too dark for your tastes, and "spotlight" any close objects that appear against it. Use the Kodak Color-Compensating gelatin filters. They come in two- or three-inch squares. CC-30 is usually dense enough. They can often be mounted behind the lens to keep away from fingerprints, dust, and spray droplets. Make sure they lie flat, and parallel to the lens surface; tape or glue them in place.

9. *Be careful* at all times. Exploring and filming underwater isn't any more hazardous than driving a car to the water's edge, but careless divers can get into trouble—from faulty equipment, taking chances, stretching physical capability, and from the few fish and animals that are potentially dangerous.

11 North American Photo Safaris

SAFARI IS a Swahili word which describes travel to the great game fields of Africa, either with gun or, more often nowadays, with a camera. These trips are costly and not everyone can afford them. But exciting and productive photo safaris are possible right here at home, at any time of the year, and virtually any American can afford one. The opportunities are almost unlimited. Consider, for example, an easy-to-duplicate safari I made in November several years ago. The first destination was Zion National Park in Utah. There in the Virgin River valley, along the same road which tens of thousands of travelers follow every summer, I found and photographed a large herd of mule deer. Earlier the animals might have been shy of all the traffic and congestion, but in late fall I had the place all to myself and shot some of my best mule deer "trophies" ever.

As already mentioned elsewhere, many of the national parks and monuments are the best places for wildlife watching and photography. But in autumn, after most tourists have gone home, some are especially productive. On the same southwestern safari which began at Zion, I shot mule deer at Bandelier Monument and Carlsbad Caverns in New Mexico, and at Saguaro Monument near Tucson, Arizona. At Joshua Tree Monument in southern California I encountered a herd of rare desert bighorn sheep which is not difficult to photograph during the dry season. Traveling through Death Valley Monument I also photographed desert bighorns, and not far from Bakersfield is a state park where a herd of equally rare tule elk may be seen at any time.

Assume that you live in the eastern half of the United States and your goal is a southwestern photo safari. Almost no matter which direction you drive westward, there are good places to shoot wildlife along the way. The Wichita Mountains National Wildlife Refuge, for example, near Cache, Oklahoma,

is a good place to observe bison, elk and longhorn cattle. Also in Oklahoma near Broken Bow is a virgin woodland known as the McCurtain County Wilderness Area. It contains whitetail deer and turkeys.

Texas is especially good photo safari country. At the Aransas National Wildlife Refuge near Rockport are deer, turkeys, javelinas, alligators—all easy camera targets—plus a possible chance at whooping cranes. The latter are among the world's rarest birds. Not far from Aransas, near Sinton, is the Rob and Bessie Welder Wildlife Foundation, a ranch where all of the same species (except whoopers) plus many waterfowl and songbirds exist. Big Bend National Park has mule deer and especially around the campgrounds, the birds have become very tame. Roadrunners and whitewing doves are especially available to photograph. A cameraman in search of African flavor can find it at Lion Country Safari near Mesquite, Texas. Here lions, rhinos and many other species of African and Asian wildlife wander about in some freedom and fairly natural surroundings. Photographers drive through the area, which is really an outdoor zoo, and stay inside their locked cars.

One of the finest and least known places to see wildlife in Texas is the Santa Ana National Wildlife Refuge near McAllen in the Rio Grande valley. It is a last remaining area of virgin "bush" and the only place this side of the border where such uncommon birds as the chacalaca, green jays, hooded orioles and other species can be easily seen. Several blinds have been built for easy photography.

In summertime, the greatest wildlife spectacles—both in numbers and variety—can be seen in such national parks as Yellowstone, Grand Teton (both in Wyoming) and McKinley in Alaska. Just drive the park roads of Yellowstone and you will encounter black bears, bison, elk and usually moose. Hike to the top of Mt. Washburn to photograph bighorn sheep which are not shy. Coyotes might be observed anywhere, but especially near Roosevelt Lodge. Canada geese and other waterfowl can be photographed along any of the Yellowstone Park rivers, with the odd chance also of trumpeter swans.

A summertime float trip down the Snake River in Grand Teton Park is almost certain to pass within close range of moose and bald eagles. But winter is the most exciting time of all to visit the Teton and Jackson Hole (as well as Yellowstone) country. During this period the brutal weather and deep snow have concentrated big game and waterfowl where it is easiest to see and approach. Annually 7500 to 9000 elk are gathered on the National Elk Refuge on the outskirts of Jackson; it is possible to get right among them via daily horse-drawn sleigh rides. Moose are everywhere in the vicinity and the best way to see them is by cross-country skiing with camera.

Glacier National Park is great for photographing spectacular scenery and Rocky Mountain wildflowers. It is also the best place to shoot goats, although it is necessary to hike (or ride horseback) to Sperry Glacier to see them. Almost equally as good as the Montana national parks for a wildlife photo safari is the National Bison Range near Moise. Besides the elk, deer and sheep, this is probably the best place of all to shoot antelope.

A series of pictures from a photo safari can tell a whole story.

Telephoto lens focuses on fox (left), blurring out background. In photo above, fox spies his prey.

Ground squirrel is alert but unaware of mounting danger.

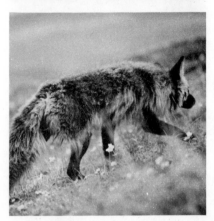

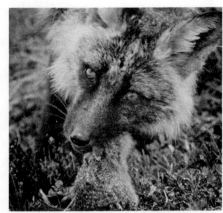

The stalking hunter is successful, and photographer with telephoto lens is, too.

McKinley in Alaska is the only place where a visitor can be almost certain of seeing a grizzly bear, probably several. It is also the only park where Barren Ground caribou (perhaps vast herds) and Dall sheep exist. Brown bears and, with much luck, wolves can be photographed at beautiful, lonely Katmai National Monument. By taking the daily boat cruises out of Bartlett's Cove, Glacier Bay National Monument, countless sea birds, harbor seals and possibly humpback whales can be shot with telephoto lenses. Both Kat-

Black bear on the run was photographed at Yellowstone National Park. An animal common to Yellowstone, these bears can easily be photographed along the road.

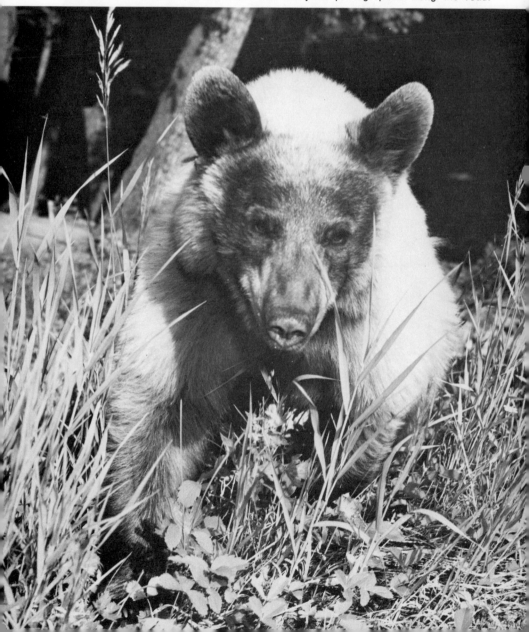

mai and Glacier Bay are also in Alaska, but are accessible only by air.

The eastern and midwestern parts of the United States are not the best destinations for a camera safari. However there are a number of scattered places where a serious photographer can make good wildlife pictures. For example, Remington Farms, near Chestertown, and Great Neck National Wildlife Refuge, near Rock Hall, Maryland, offer many opportunities to shoot waterfowl, especially in autumn. A spring fed pond inside the northern

Whitetail deer can be hunted with camera in many wooded areas throughout the country as well as state and national parks and wildlife refuges.

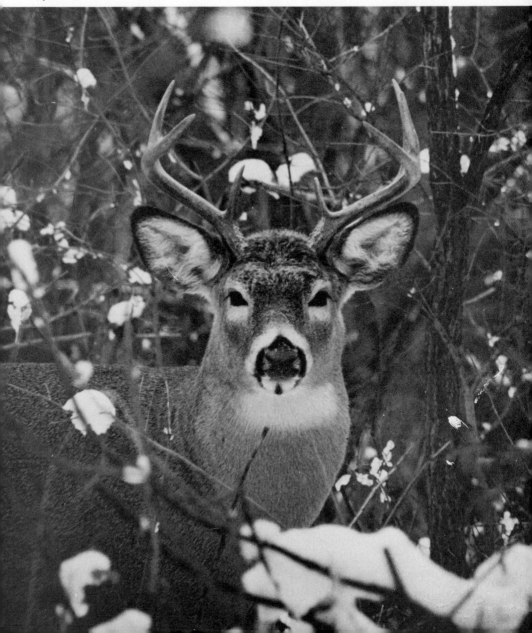

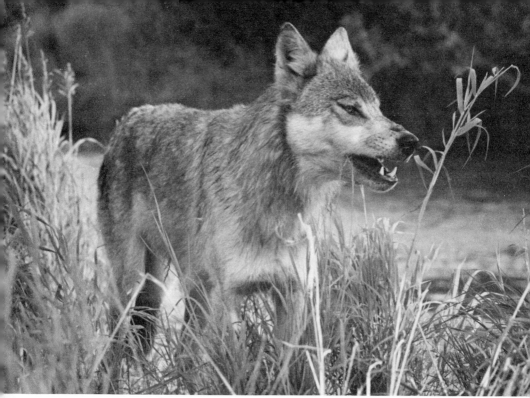

This timber wolf was photographed at Katmai National Monument, Alaska.

Bull elk "poses" for photographer at Yellowstone National Park.

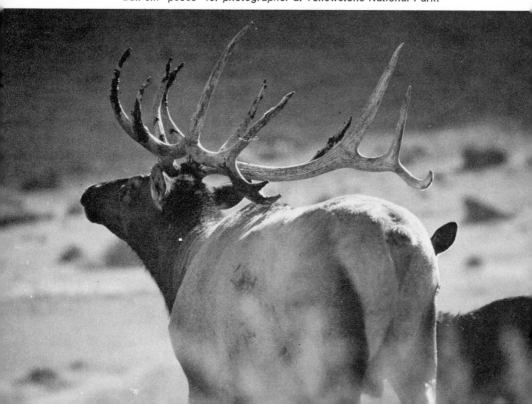

Ohio village of Castalia usually contains a large number and variety of ducks which have become used to people. Great Smoky Mountains National Park is worth visiting, especially in the fall.

Despite the degree to which it has been developed and despoiled, Florida remains (for the time being at least) a good place for wildlife photography. Opportunities are unlimited at Everglades National Park. The best bet here is to hike the Anhinga Trail from which alligators, turtles, occasionally otters and dozens of different kinds of birds are in evidence. The tidal ponds near Flamingo also contain many water birds, including the spectacular roseate spoonbill.

Farther north in Florida, the Myakka River and Highland Hammock state parks have much wildlife which is not too shy. Better still is the Corkscrew Swamp, a National Audubon Society refuge between Naples and Immokalee. Besides alligators, raccoons and squirrels, there is a variety of wildlife here difficult to match anywhere.

There are a good many photo safari opportunities in Canada, but as in the United States, the best and most are in the West. Alberta's Banff and Jasper national parks contain bears, elk, moose, goats and bighorn sheep, all of these being easiest to see near the roads late in the season after summer-time tourists have gone home. During midsummer, it is best to hike or ride out along the mountain trails to see wildlife. Tiny Elk Island National Park near Edmonton has a wild buffalo herd and a good variety of waterfowl. Waterton Lakes National Park is a good place to find bighorn sheep.

The possibility of winter photo safaris should never be overlooked, especially now that more and more places are becoming accessible during the cold months. At Yellowstone, for instance, it is possible to visit Old Faithful via snow cruiser and to overnight there at snug Snow Lodge. Snow cruisers make the trips daily from West Yellowstone, Montana, and Jackson, Wyoming. Much wildlife is seen along the way. Every day there are ranger-naturalist guided trips either on snowshoes or cross-country skis which take a photographer very close to elk, bison, mule deer and waterfowl along the Firehole River. The entire Yellowstone country is never more exciting and beautiful than when in the grip of winter.

Keep in mind that photo safaris take the outdoorsman to the scenes of greatest natural beauty left in America. Why not make the most of them?

12 How to File Photographs

EVERY PHOTOGRAPHER should devise an efficient filing and storage system for his pictures to protect them against dampness, heat, and excessive light, and to enable him to locate a particular photograph at a moment's notice.

If your home has more than one story, keep the film (black/white as well as color) on the lower story, if possible, because it will be much cooler there. If you live in a very humid area, it is wise to purchase a dehumidifying device to absorb moisture. These are handled by most large appliance and photographic stores, and some pharmaceutical firms.

The best place to file either color or black/white is in a good photo album. Arrange the prints in chronological order and label them in detail. Give the time, place, persons involved and any other circumstances. As time passes, photo albums have a habit of becoming anybody's most precious personal possession.

The importance of labeling in detail cannot be emphasized enough. Also, as time passes, a person's memory grows poorer. The notations in a photo album can become extremely important in the future.

Slides are fairly easy to file. Most photo-finishers return them to the photographer in handy boxes with space provided on the outside for labeling. After the labeling is completed, the boxes can be stored in lightproof drawers or filing cabinets. Try to keep them in alphabetical order.

Slide filing and storage has been made even easier for owners of the newest projectors. The slides are inserted (sometimes in glass-enclosed slides) in magazines or trays and these in turn are "fed" into the projector. The magazines or trays, which provide labeling space, also serve as filing devices.

We should insert a word here about projecting slides, which *never* should be left in the projecting position longer than absolutely necessary. Also, use a blower-cooled projector, and never use a lamp of greater wattage than recom-

mended for the particular projector. Stronger lamps produce more heat than the projector's heat-absorbing glass can stand; the result is that film can actually be scorched or burned outright.

Black/white negatives and unmounted color transparencies require more elaborate filing facilities. The most meticulous photographers file each individual picture in a transparent envelope, label it and then keep it in alphabetical order in filing drawers of suitable size. That is the best and most accurate way. Every photo is always handy in an instant.

However, the photographer who shoots a multitude of pictures may be unable to file each picture separately. He may find it best to file all the pictures made during one event or one trip or one weekend in a single envelope.

Let's use the example of a fishing trip photographed the previous summer. All pictures of that trip will go into a single filing envelope. And it will be labeled in this manner for instant reference anytime:

"FISHING, smallmouth bass, perch, Lake Erie near Pelee Is.

Frank Sayers, Glenn Lau (swim trunks), Paul Griffith

(yachting cap), Tom Reynolds (striped shirt).

June 17–18, 63. Also Pelee scenes, sunset."

This caption gives all pertinent information. Brief descriptions will help you identify the fishermen at any time in the future. The envelope will be filed alphabetically.

All film should be handled carefully. Dust and fingerprints are every cameraman's bugaboo, but scratching is even worse because it cannot be repaired. Be extremely gentle in handling film and try to touch it only on the edges. Film cleaner is available in most camera shops to remove dust and finger marks.

When you expect color transparencies to be handled, as when submitting pictures to a magazine for publication, you should always cover them with transparent protectors. There are little acetate sleeves made for 35mm slides, called "Kimacs," which fit snugly over the mounted slide and protect it against fingerprints and dust. These can be left on and will feed through most projectors. Larger transparencies should be put into "Kodapak" sleeves sold by photo stores, and secured with a small bit of tape so they won't slide out the end. You may prefer to tape them by the edges to a white cardboard cut-out mount, and slip a 4x5 Kodapak over the whole thing; captions and numbers can be written or typed on the cardboard. It's a wise idea, if you're lucky enough to get a once-in-a-lifetime shot, to have several duplicates made in case the original is lost in the mails or burned up accidentally.

Index